COLWYN BAY AT WAR
From Old Photographs

GRAHAM ROBERTS

AMBERLEY

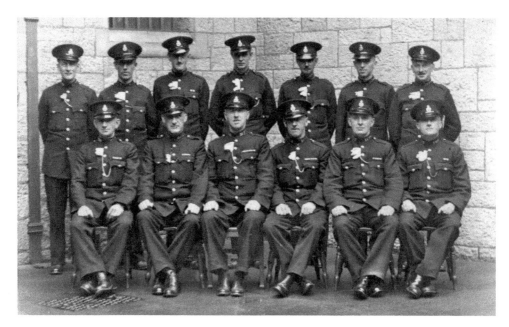

Police War Reserves and Special Constables photographed in the cell block exercise yard at the Rhiw Road Police Station in 1940. Back row third from left: Jack Allen of Daniel Allen's department store on Station Road. Sixth from left: Kitchener Jones the gardener from Nant-y-Glyn Hall. Front row fifth from left: Len Firth the future Mayor of Colwyn Bay. Sixth from left: George Whitehead the owner of the Fish and Chip shop on Park Road.

For Gavin and Alice
Whose grandmother, Olive Roberts,
worked in the Catering Division

First published 2012

Amberley Publishing
The Hill, Stroud
Gloucestershire, GL5 4EP
www.amberleybooks.com

Copyright © Graham Roberts, 2012

The right of Graham Roberts to be identified as the Author of this work has been asserted in accordance with the Copyrights, Designs and Patents Act 1988.

ISBN 978 1 4456 0770 2

British Library Cataloguing in Publication Data.
A catalogue record for this book is available from the British Library.

Typesetting & Origination by Amberley Publishing.
Printed in Great Britain.

THE OCCUPATION

Colwyn Bay lies in a wonderful spot on the sunny coast of North Wales, way away from the large industrial cities of Great Britain and yet with direct railway links to them all. By 1939 the town had become a very popular holiday resort so there were many good hotels and bed and breakfast establishments ripe for immediate occupation by large numbers of people. It was the sort of place that if you wanted to shroud your work in secrecy you could safely get down to work unmolested by prying eyes and curious nosey people. These were the favourable signs that the government decided would allow the Ministry of Food (originally known as Food Defence Planning) to carry out its vital task in private and without being disrupted by enemy action. On 11 November 1940, a Mr Johnson wrote from the Burma Office in Whitehall to the office of the Ministry of Food in London requesting some information about the Ministry of Food. Mr Hutton replied, 'My difficulty arises partly from the fact that we have no information as to what has happened to the Ministry of Food. We do not know the function of that part which has remained in London, what divisions are at Colwyn Bay or what are their functions, nor do we know where the other divisions are or what they do.' If the civil servants were confused what chance did Hitler have! Sir Winston Churchill called battlefields 'the punctuation marks of history'. For Colwyn Bay, although no battles were fought on its beaches, the Second World War was a definitive punctuation mark in its history; it remains something of a miracle that we survived the fiasco which took us to Dunkirk and then back to Normandy, and one of the ingredients of our survival was stirred here in Colwyn Bay.

In April 1940 Neville Chamberlain appointed Lord Woolton as his Minister of Food and Winston Churchill retained him in this office the following month. Lord Woolton then almost immediately sent his requisitioning officers to Colwyn Bay to turf out the residents of the large houses, the guests out of the hotels and the pupils out of the two large public schools, Rydal and Penrhos, so that his 5,000 civil servants, who arrived at Colwyn Bay railway station wearing their city suits, starched shirts, ties and Anthony Eden hats, with Brylcreemed hair and carrying, so the local paper reported, 'their brief cases and rolled umbrellas', could get down to work. The newspaper described them as 'aliens in an alien land of churches, chapels and pubs'. In 1820, Beau Brummel sold out his commission in the 10th Light Dragoons when they were posted to Manchester, on the grounds that he had 'not enlisted for foreign service'; in 1940 that would have been a sentiment shared by many of the newly arrived civil servants in the nether regions of North Wales. Amusingly, train loads of thick brown linoleum also arrived at Colwyn Bay railway station to be used on the floors of the Ministry's offices. Some of this

stuff still remains to this day. Had Hitler bombed Colwyn Bay as comprehensively as he did Coventry, he would have created far more havoc. There would not have been as many immediate fatalities, but the British people could have faced starvation, such was the importance of Colwyn Bay in the organisation of the distribution of food, and the propaganda directed at the people of Great Britain to educate them to feed themselves.

In many ways, what went on here in Colwyn Bay during the war changed forever the British people's relationship with food; city parks dug over for crops, suburbanites transformed into smallholders growing their own food, everyone reading books with titles such as *Twenty-Five Ways of Serving Carrots*, and rationing emphasising the value of everything. In the end there was no British famine, and we have rationing, the Atlantic convoys and the hard work of the Ministry of Food civil servants working away in Colwyn Bay to thank for that.

The civil servants of the Ministry of Food were beaten to Colwyn Bay by hundreds of evacuated children from Liverpool who arrived in September 1939. One of these young children was Charles Crump, who could remember having to line up on the station platform with all the other children while ladies and gentlemen walked up and down the line choosing who they imagined would make the least trouble in their homes. Charles was mortified to be one of the last to be chosen; however, he remained here for the rest of his life and became the Borough Treasurer and a local magistrate.

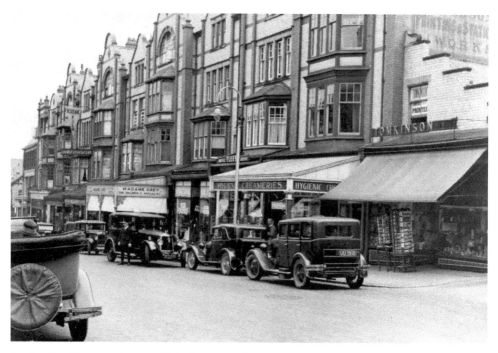

Penrhyn Road between the wars. All the businesses shown in the photograph have gone while the buildings remain the same. The shops survived the war due to the arrival of so many civil servants.

The most telling description of the mood of the British Home Front during the Second World War was endurance and defiance, but in Colwyn Bay this mood was modified by hard work and also by much enjoyment. The arrival of the civil servants of the Ministry of Food added and enhanced the social life of the town and made the war not only an anxious time but an exciting time as well.

George Orwell described the year 1938 as 'a scenic ride to catastrophe'. For Colwyn Bay, however, it was the beginning of five exciting and exhilarating years. Those people who change the world do not necessarily do it with a bang; sometimes they do it when people are looking the other way. But it still changes. Colwyn Bay helped change the world and most of the world knew nothing about it.

THE BRITISH PEOPLE WERE FORTUNATE

The people of Britain loved to grumble about queuing for their mince or not being able to remember what a banana looked like, but they never came close to having to decide which child to feed and which to abandon to almost certain death. At one stage during the war, in Japan, the civilian population was ordered to eat snakes, rose petals

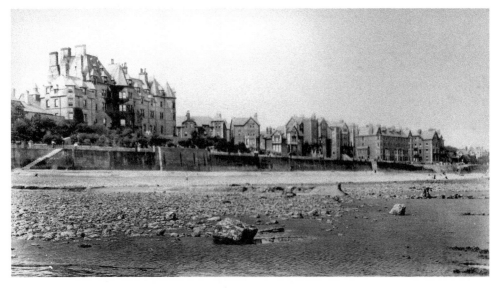

The picture above shows the promenade at the bottom of Marine Road (which was the first part of the promenade to be constructed) in 1939. The Colwyn Bay Hotel is on the left and housed the headquarters of the Ministry of Food; second from the left is the St Enoch's Hotel, which became the Transit Camp for the male civil servants. On the far right, at the bottom of Penrhos Avenue, is the Rothesay Hotel, which was requisitioned by the Ministry of Food and on the far right is Gilbertville which was where Penrhos College started its life.

and sawdust. Only fighting men got what scraps of real food still remained. Britain was probably the only country in Europe never in danger of starving during the war, thanks to the organisational skills of the civil servants working in Colwyn Bay, to our fertile soil and continuing trade links with the rest of the world. In 1939 Britain only grew enough food to feed one in three of its 48 million people. But thanks to increased productivity reliance on imports was halved by 1945. Ten thousand square miles of pasture was brought under the plough and Britain's agriculture became the most mechanised in the world. This great effort was galvanised and organised from within the hotels and schools of Colwn Bay.

THE GENTLEMEN'S TRANSIT CAMP

Until more permanent billeting arrangements could be made the male civil servants who had arrived from London were hastily given accommodation in St Enoch's Hotel on Marine Drive. This was a particularly handy arrangement as the hotel was just across the road from the headquarters of the Ministry of Food in the Colwyn Bay Hotel, so bleary eyed Londoners could be seen in the dawn light stumbling the hundred yards to work to start their day and contribution to the war effort. Three of the main

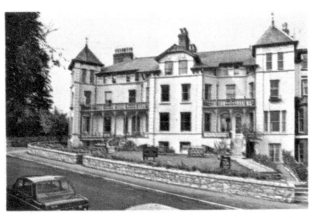

St Enoch's Hotel.

'billeting officers' who found accommodation for these new arrivals were the Colwyn Bay librarian, Revd Ivor Davies (who walked around puffing on a Sherlock Holmes pipe), the manager of the Midland Bank, Mr O. A. Evans, and the manager of Barclays Bank, Jack Thomas. It was felt they had sufficient gravitas to be obeyed by reluctant householders.

The Desk: This was in fact a room in the Colwyn Bay Hotel in which six Executive Officers, some living temporarily in the St Enoch's Hotel, were coding and decoding the numerous cables from all over the world on food purchases and shipments. They had copies of all the code books in use by every government department, services department and commercial business both in Britain and the Colonies and most foreign ministries which were supplying the United Kingdom either in shipping foodstuffs or other war material. Arthur Victor Groves, the senior man on 'The Desk', became an expert at breaking foreign codes. All the messages would be decoded and then the despatching clerks would jump on their bicycles and distribute them to the correct division in the requisitioned hotels and schools throughout the town, responsible for any aspect of the ordering, importation and distribution of every item of foodstuff coming into the country. The officers discovered that they were most busy at night, as the long daily cables from the food missions in Canada and the USA, which were anything from 1,000 to 20,00 words each, normally came in at night and had to be ready for circulation in the morning.

THE LADY'S TRANSIT CAMP

It was 1939 and it was considered unseemly to put the male and female civil servants together in the same lodgings. Seventy ladies ended up, within an hour of arriving at the railway station, in Plas-y-Coed Private Hotel in The Dingle. The manager, Mr J. Royle, was overwhelmed with a huge crowd of ladies from London who were not used to the local Welsh customs and diet. Mrs Abel was the strict resident hostess who made the ladies 'sign in and out' and who sent one girl home for becoming pregnant. The evacuation to Colwyn Bay, a strange land for most of them, changed these ladies lives forever; this was where their emancipation began. Some became GI brides and eventually travelled to America. Some of the civil servants were found accommodation in Rhyl and were brought to Colwyn Bay each day by train and coach. The hotel overleaf has now been demolished and the land remains derelict. The lower picture shows some of the typists in the back garden of Plas-y-Coed.

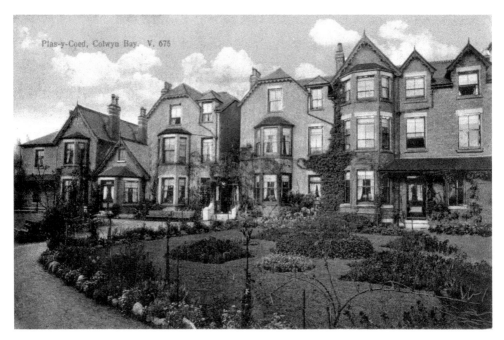

Ladies' transit camp.

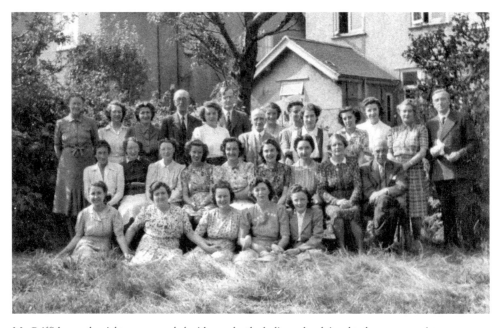

Mr Griffiths, on the right, was regarded with awe by the ladies as he claimed to be a communist.

THE EVACUATION OF RYDAL SCHOOL

The arrival of the Ministry of Food in 1939 meant that the headmaster, Revd A. J. Costain, and the governors of Rydal School had to quickly find alternative accommodation. The dilemma was solved when they decided to use two empty hotels, Oakwood Park, and purely as a building in which the boys would sleep, Pinewood Towers, in the Sychnant Pass on the other side of Conway. The junior school was allowed to stay in Colwyn Bay and use Walshaw on Oak Drive and Beech Holme on Pwllycrochan Avenue, and later, after the Ministry decided they no longer required it, Hathaway on Lansdowne Road. It was a huge task to move all the school equipment but the move from the town to the countryside was completed in two weeks with the help of the Ministry of Works who supplied a cohort of muscular men and lorries. As the school impedimenta was being moved into the hotel at one end, so the hotel equipment was being moved out at the other end. The hotel ballroom became the assembly hall, the master's common room had, throughout the war, a notice on the door which read 'Stewards' Room', and the exams were held in the large garage. Ironically, from 1939 to 1945 the number of pupils rose from 195 to 228, an increase which was due to the arrival of the married Ministry of Food civil servants who sent their sons to Rydal, and to other parents who were happy about the remote location of the school which made

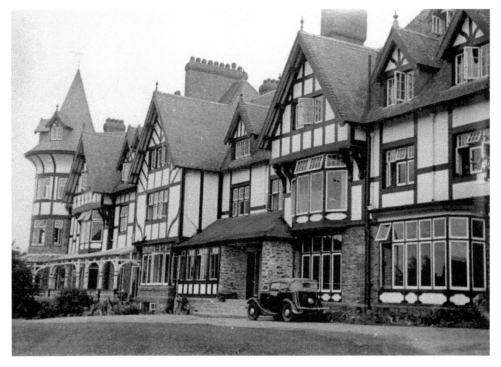

Oakwood Park in the Sychnant Pass, Conway, in 1943, when occupied by Rydal School. The car belonged to Frank Richards, the geography teacher.

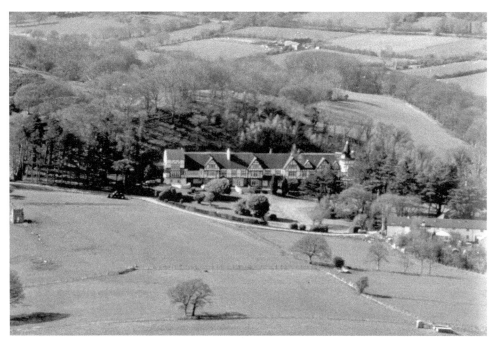

Oakwood Park, May 2011. The top floor of the building was modified in the 1970s.

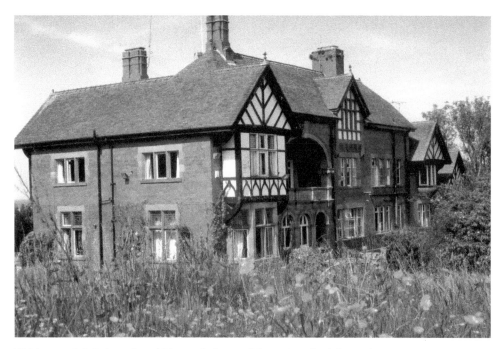

Walshaw on Oak Drive today, which was the home of the Junior School during the war.

it safe from enemy attack. On VE Day the celebrations included a huge bonfire on the golf course. In 1946 the Senior School returned to Colwyn Bay and the Junior School moved to Oakwood Park, where six years later I found myself working reasonably hard and playing football on the golf course.

REST AND RECREATION AT RHOS PRIORY

During the war, Rhos Priory (below) was used by the forces as a hideaway for recuperating soldiers, airmen and sailors. They were well away from the fighting, the air was bracing and the former hotel's facilities were ideal for weary men and women. Many civil servants from the Ministry of Food volunteered to help with the care of the resting men and women, as did many locals. One of the airmen who came to recharge his batteries in 1940 was Douglas Bader. He had lost his legs before the war began but had persuaded the RAF that he could still contribute to the war effort. There is still a lady in Rhos-on-Sea who goes misty eyed when recalling dancing with him in the Rhos Priory Hotel and at the memory of how nimble he was on his two tin legs. On returning to his squadron and taking to the skies again he was shot down on 9 August 1941 and was imprisoned in Colditz Castle until the end of the war. Rhos Priory was torn down in 2008 and the site is now home to a posh block of flats and the dancer became Group Captain Sir Douglas Bader, CBE, DSO, DFC.

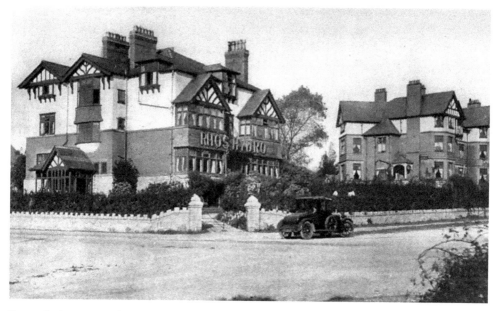

Rest and relaxation at Rhos Priory.

Adlington House, above, are the flats that have been built on the site of Rhos Priory.

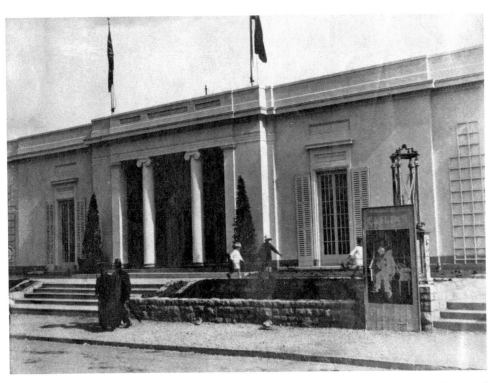

The Arcadia Theatre (*c.* 1928) designed by Sidney Colwyn Foulkes for Will Catlin, was on Princes Drive and was demolished to make way for the A55 road. It was a favourite haunt of many of the men and women recuperating at Rhos Priory. During the war it was run by Harry Hymanson, who would open the cinema late at night especially for the Jewish community who worshipped at the synagogue across the road in the building (No. 37) next door to the Norfolk House Hotel.

At the request of the government, Women's Institutes throughout the country set up a network of 5,800 'preservation centres' to prevent fruit from going to waste. One such centre was in the basement of the Rhos Priory. Fortunately, this fact was kept secret from the hungry war time guests. It was because of schemes such as this that Dr Magnus Pyke was able to write in his 1981 memoir, 'it was generally accepted, as Britain stood alone against the foe, beleaguered and bombarded, that the figures for infant mortality and, indeed, virtually all other indications of nutritional well being of the community, showed an improvement on the previous standards'.

THE IMP

The Imperial Hotel on the corner of Station Road and Prince's Drive was built at the end of the nineteenth century and has been, up until the present day, one of the pre-eminent social centres of the town. The building is now empty and for sale. During the war this was the headquarters of the Merchant Navy Control where the civil servants monitored the merchant ships sailing into and from Liverpool. Many local young ladies were recruited to act as secretaries and typists to the efficient and punctilious London

1940: A view from The Imp looking towards the railway station.

The arrival of two new civil servants waiting for their taxi and looking across at the Imp.

men from the Ministry of Food. At the end of the war some of these efficient young men took some of their secretaries back to London as their wives. Some of the London civil servants were women, many very young and away from their families for the first time, who proceeded to thoroughly enjoy their stay in Colwyn Bay. One of the other tasks carried out in the Imp was to try and assess the dietary necessities of an average person so that a common ration book could be produced. After much discussion it was decided that the six main categories or coupons shown in a book should be: meat, eggs, fats, cheese, bacon and sugar, with one space left for 'spare'. The picture on page 13 shows the view from the Imperial, with Victoria Drive on the right leading down to the promenade, as the secretaries amble across to the railway station.

Sixty-eight years ago, a landlady, Edith Olivier, wrote: 'There are two phrases which will be forever inscribed in the hearts of wartime housekeepers – shopping bag and queue. Lord Woolton has decreed that 'man shall not live by bread alone', but I think he favours women living by the queue and the shopping bag.'

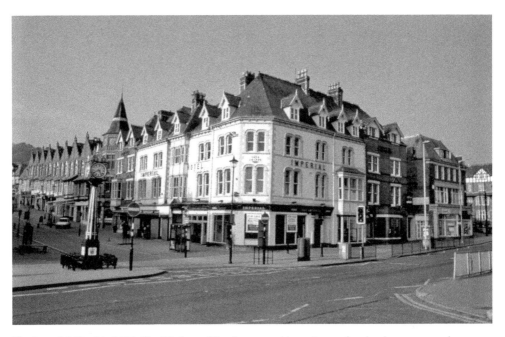

The Imperial Hotel in 2011. The Ministry of Food personnel have departed and so has everyone else.

THE TOWERS HOTEL THE EGG DIVISION

The Towers (on Whitehall Road, Rhos-on-Sea, on page 16) was next door to the Mount Royal Tea Division and so there was much socialising between the clerks from the two hotels. Mrs H. Thomas, the proprietress of the Towers was told to vacate her hotel and find somewhere else to live within 24 hours of receiving the visit from the Ministry of Food requisitioning officer. Although the department was called the Egg Division, it should have been named the Powdered Egg Division. There had been a mass slaughter of hens at the beginning of the war because they consumed too much precious grain, and so most people had to subsist on the powdered variety of egg. Colwyn Bay, however, was then, as it still is today, surrounded by many small farms, and it was not too long before the local residents were able to find sympathetic farmers who would supply them with secret, proper eggs. One of the civil servants in the Egg Division was Hector St George Spearing, who had arrived from Southampton where his cold storage business had been bombed to smithereens. His daughter, Patricia, worked next door in the Tea Division and his other daughter, Nora, was on the other side, in the Cereals Division, in the Mount Steward Hotel. Nora would later marry Ken Dibble from the Animal Feeding Stuffs Division. Three men were in charge, Jack Peacock, Alec Paul and Lesley A. Garrard.

Many of the local girls were amazed by the relative sophistication of their London counterparts. They stared in awe at the ones who were smartly dressed and who had mauve hair.

The Towers Hotel.

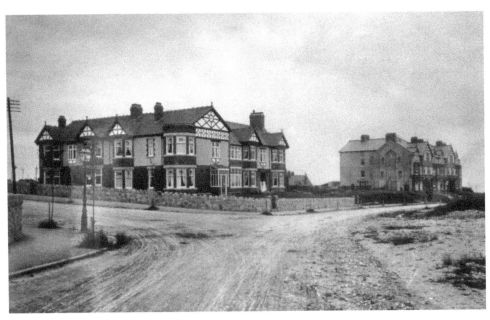

Whitehall Road above *c.* 1925 and opposite in December 2010. During the war these buildings were full of workers working away in such departments as the Tea and Egg Departments, to make sure that the people of Great Britain had enough to eat and drink.

During the war, if the civil servants or typists were sick and could not get to work, they did not have to produce a medical certificate until the fourth day of absence. Fragile types were entered in the register at the Towers as suffering from resurrection sickness, i.e. on the third day they rose again. Others, who were given to enjoying their weekend social life in a vigorous fashion on Colwyn Bay Pier or at the Penrhos dances, were entered as suffering from the DCMs (they don't come Mondays).

PENRHOS COLLEGE EVACUATED TO CHATSWORTH HOUSE

In 1939 the headmistress, Miss Constance Smith, was informed that the Ministry of Food intended to take over the school buildings (except for part of the sanatorium and the Junior School) and that she and her staff had 10 days to pack up and leave. The Duke of Devonshire had thoughtfully agreed to allow the school to use his ancestral home, Chatsworth House in Derbyshire, for the duration of the war. Convoys of lorries and removal vans travelled night and day to complete the exodus from Colwyn Bay and the staff and prefects made sure that everything was in place for the start of the September term of 1939. One of the pupils, Dorothy Drake, remembers being very impressed with her new surroundings and how that first winter was incredibly cold;

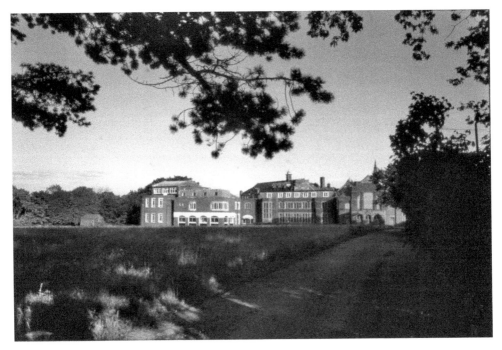

The school is pictured above in 1940 empty and awaiting the invasion by the Ministry of Food. All the school buildings have now been demolished and the land is covered by a housing estate. The school chapel is on the right hand side of the picture and the field in the foreground was used as a hockey pitch and the place where the girls congregated in strict regimented rows whenever there was a fire alarm practice. The view is shown looking from Llannerch Road East; at this spot today there is an interesting information board. The local police force did not like Penrhos, because, due to there being so many doors in the building, it took the police men hours to check them all at night.

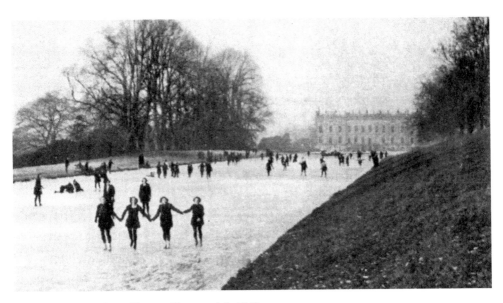

The girls skating on Long Water at Chatsworth in 1942.

The school in Colwyn Bay just before demolition.

so cold that, due to hunger, the deer in the park chewed the saddle-bags off their bicycles. The girls learnt to swim in the Horse Fountain and in the pond in the Sunken Garden. Mr Francis Thompson, the Librarian and Keeper of Collections at Chatsworth, arranged displays of snuff boxes and miniatures and rare and valuable documents for the education of the girls. The Head Gardener sold the girls potatoes which they baked on the form-room fire, and grapes which they gave as presents to their parents. The school's wartime association with the Duke's home is recalled in the name of the road in Colwyn Bay which now runs through the housing estate where the school once stood: Chatsworth Avenue.

One of the teachers at Chatsworth House was a young German lady, Scholto Elizabeth Brandenburg, who at Miss Constance Smith's insistence had managed to get out of Germany in 1939 on one of the last passenger airplanes to leave that country. She was billeted in the local village in a house whose owners would not speak to her because she was German. They also accused her of opening the curtains at night to signal to German bombers.

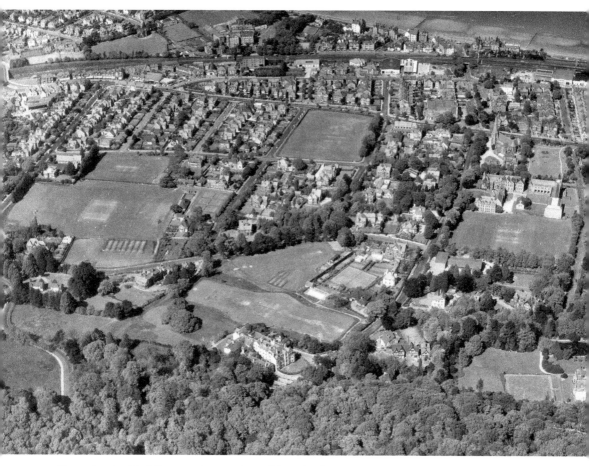

The main school buildings are shown in the middle right of the picture above. The junior school is bottom middle, just above the tree line. Pwllycrochan Avenue, running down the hill from the junior school to Conway Road, was, in the early nineteenth century, the original drive way from Erskine House (the junior school) across open fields down to the main road, Conway Road. At the end of the drive were two large gate-houses, both of which have been demolished to make way for the Rhoslan flats on one corner and the Swn-y-Mor flats on the other corner.

RYDAL SCHOOL AND THE BLACK PUDDING DEPARTMENT

The Meat and Livestock Department of the Ministry of Food was housed in the Rydal School new building, designed by Sidney Colwyn Foulkes. This is now the science block. One of the clerks was a local lad, a Temporary Grade 3 Clerk from Old Colwyn, Gwilym Pritchard; he would check the expenses of the local butchers and supervise the Local Meat Agents who were engaged in checking other butchers and their supplies to make sure that they were complying with the rules and regulations of the day. The clerks also checked the abattoirs to make sure that they were stirring blood properly with which to make black puddings. Mr Samuel Brown Stevenson was in charge of this particular department and travelled each day to work, from his home, in the old

Telegraph House on top of the hill above Llysfaen. After the war was over his son Mike became a schoolboy in Rydal and went on to become a Derbyshire County Cricketer and cricket correspondent for the *Daily Telegraph*. Gwilym, the young clerk, travelled every day by bus from the Ship Hotel in Old Colwyn to St Paul's Church, Colwyn Bay, on a monthly bus ticket which cost five shillings and allowed him to travel as often as he liked. He remembers that it was only 3/6d a month if you travelled from the Marine Hotel instead of the Ship. Gwilym subsequently joined the navy, was present at the D-Day landings, then came home and became a highly respected local solicitor.

STRATEGIC PLANNING AT PENRHOS COLLEGE

Muriel Griffiths was in charge of a group of ladies who, in the Sixth Form School block, monitored the bombing of our cities. They were in charge of the distribution of bread and milk to the beleaguered cities. When, for example, Manchester was bombed, they would gather around a large map of Great Britain, place the pointer of a compass

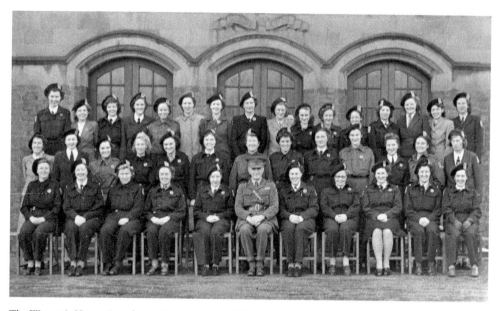

The Women's Home Guard Auxiliary Group in 1942 shown outside the Penrhos College Hall. The Hall was opened on 10 October 1925 by Lady Wakefield and it was demolished in the spring of 2002. The Hall's magnificent stained glass windows are now shown to good effect in Rydal Penrhos School. It had been designed by Ernest Whitfield who also designed the Elwy Road Church House. His office was on Conway Road where now you can find the Mayfair Dress Shop. These were the days when the clerks in the Ministry of Food could buy the Ideal Automatic Pin Box from Herbert Tomkinson Ltd in Penrhyn Road for 2/6d; they could also purchase Japanese cakes at Buckley's Café (now part of the NatWest Bank building) and 'dainty scarves' for 2/11d from Slater's House of Fashion on Abergele Road. This was a darn sight cheaper than they would have had to pay, had they stayed in London.

on Manchester and then draw a large circle around the city. They had the definitive list of all the bakers and dairies in the British Isles and they would then arrange for extra supplies of bread and milk to be delivered by all the named suppliers lying within their circle of the city. It was hard, concentrated work and for a long time meant being on duty every night. Also based in the school buildings was the 'Margins Committee' which examined the profit margins permitted for various types of food, making sure that rationing rules were strictly obeyed.

THE HATHAWAY FIRE WATCHERS

All the properties used by the Ministry of Food had to be watched over at night in case there was a fire. Hathaway, on Lansdowne Road, was one such establishment. It had been a Rydal School boarding house before it was requisitioned and now, in 2011, it is once again. The fire watchers tended to be young ladies. One such girl was the eighteen-year-old Nellie Garrat who had arrived from London with the Ministry and was employed as a telephonist. In the evening she received 1/6d subsistence allowance for standing on the roof of Hathaway to watch for enemy planes. As the Germans had not cottoned on to the fact that the whole of Colwyn Bay was being used as a base

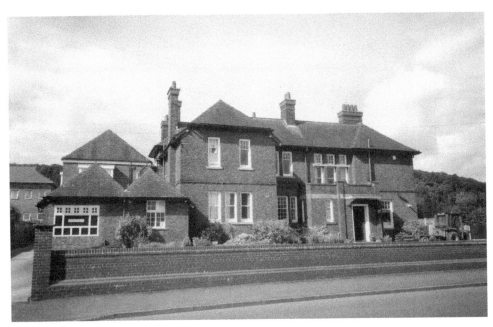

Hathaway in June 2011. Olive fire watched from the flat roof above the doorway.

to organise the feeding of the British people they left the town unscathed. As Nellie reported later: 'We hardly ever saw a plane, let alone the fall of a bomb.' One of Nellie's fire watching companions was another eighteen-year-old Olive, who remembers many cold and boring nights. One evening the married civil servant who was in charge of the Hathaway operation took pity on her and loaned her his dressing gown as an extra layer of warmth. There was much merriment the following morning as Olive and her friends spied the thoughtful man vigorously shaking the garment out of the window in an effort to shake off the smell of Olive's perfume before his wife got wind of it!

One of the Ministry officials working in one of the town's large buildings, such as Hathaway, was a London grocer, Harry Morrison. He was one of seven children, the son of a policeman, brought up in Brixton and he was the elder brother of Herbert Morrison, the wartime Minister of Supply and future Home Secretary in Churchill's government. He was a keen snooker player and while with the Ministry he used to play the game at Rhos-on-Sea Bowling Club pavilion. He so enjoyed his time at the club that in 1941 he donated the 'Morrison Snooker Cup' to be competed for each year. Herbert described Harry's boss, Lord Woolton, as 'pleasant but somewhat portentous', but then Herbert had to deal with him at Cabinet meetings, whereas Harry dealt with him at arm's length.

INGLESIDE

This was a Rydal School boarding house, on the corner of Lansdowne Road and Brackley Avenue, presided over by Donald Boumphrey and handed over to the Ministry in 1940. It was from here that Mr Rosevear, a Cornishman, directed plans to coordinate all the differing food boards in all the Colwyn Bay buildings. Olive Marsden wrote from Timperley in 1939 to her friend Olive Roberts in Rhos-on-Sea, 'quite a number of people seem very optimistic about the whole thing being over and done with by Christmas – We shall see what we shall see'. For the next five years the civil servants in Colwyn Bay worked hard to make sure that the two Olives and the rest of the British people were sustained by wholesome food. There was no proper yeast, so the bread that was baked was yucky, fluffy and tasteless. Everyone, however, simply got on with it and ate it. A rumour was passed on to Lord Woolton that baked in this fashion, the bread was an aphrodisiac, and that may have helped!

There was also an 'analysis department' in Ingleside where the civil servants assessed the number of ships needed to ferry food across the Atlantic. The government required an assessment from the Ministry of the food which it felt it was essential to import, estimating separately the amount to be imported from each of the main source countries. Canadian public opinion became somewhat concerned by the implications for the Canadian wheat industry due to the sale of foodstuffs from the United States to Great Britain. However, what the Canadian public thought of all this was of no concern to the civil servants working away in Ingleside.

Ingleside.

When the Rydal boys returned to Ingleside in 1947 they were greeted by Mr Boumphrey and the new house matron, the formidable Miss Gertie Senior, who had a parrot. Over the ensuing years the ever resourceful boys taught the parrot some appallingly risqué phrases and words.

THE NORFOLK HOUSE TYPING SCHOOL

Hundreds of new typists were required for the Ministry of Food and so this hotel was requisitioned to house a school specifically to teach young ladies how to take dictation and how to use a typewriter. Once they were able to type fifty letters a minute they were deemed to have passed the course which lasted eight months. All the students were ladies and they mastered their new skill to the sound of music. Seventy years later, one of the young trainee typists, Megan Conway, remembers it as being a 'wonderful time'. To keep up the demand for typists the school had to churn out several hundred students each year, before they were moved on to the Colwyn Bay Hotel or the Mount Stewart (where Megan went) or the Metropole Hotel or the Pwllycrochan Hotel or the Brooklands or the Queens Hotel, etc. It is interesting that although the general public wondered whether

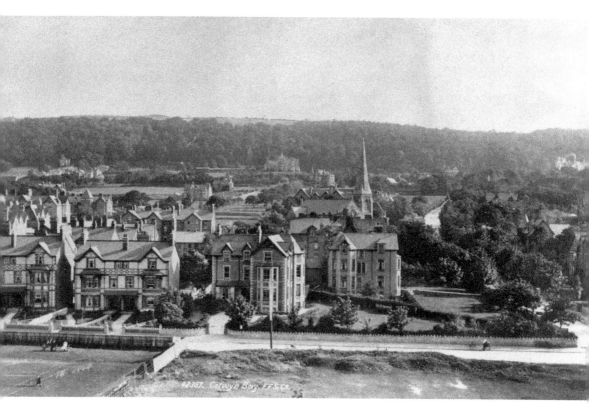

Norfolk House.

the war would last until 1940, it was evident from the length of the typing course that the government were well aware that it was going to last for some years.

Norfolk House Hotel is the building in the centre bottom of the picture above with Princes Drive running from left to right. The house on the bottom left hand corner of the picture (now 33 Princes Drive) was known as Zion House and was used by the new Jewish arrivals who came with the Ministry of Food. Before 1939 most people in Colwyn Bay had never met a Jewish person; this was such a novelty to the locals that they nicknamed Colwyn Bay, Cohen Bay and Llandudno, Llanyiddno. Hans Wins, a Jewish refugee from Antwerp, was known by the local boys as 'Dutchie' because they did not know the difference between Holland and Belgium. There were no privileges that the Jews were denied. They expected their beliefs and rituals to be tolerated and accepted, and that is what happened. The local people looked at these new arrivals with a curious fascination, but no hostility. During the war, Mr A. Levy, a Jewish gentleman from Manchester, leased Wern Farm in Mochdre and installed his wife, son and daughter in what they called their 'summer house', Seafield (now 109) on Marine Drive in Rhos-on-Sea.

Merton Place.

MERTON PLACE AND THE FOOD DECEPTION DEPARTMENT

Napoleon famously said that an army marches well on a full stomach. It was from this large house on Pwllycrochan Avenue, on the opposite side of the road from Rydal School, that the civil servants of the Ministry of Food organised a type of campaign to convince the people of Britain that a sparse healthy diet would be good for them, while at the same time ensuring that the fighting troops received a far better and richer mix of food. It was a balancing act between maintaining the morale of the people at home and maintaining the strength and morale of the Army. Interestingly, the civil servants were helped in this endeavour by the British class system which was still endemic in these islands in the 1940s. Today, in the early twenty-first century, we have become a nation of all-day eaters; the classless society has made us fat. During the war, British life was more prescriptive and it was customary, and a habit, for the working class family to eat only at regulated meal times while the middle classes used to drill their offspring not to eat between meals and 'spoil their appetite'. These stringent class rules made the work of the Merton Place bureaucrats a lot easier. Towards the end of the war a well off American, Margaret Cotton, living in London, reported: 'the pinched, or the puffy (varying with individual metabolism) look upon people's shadowed faces produced by a diet unhealthily heavy in starch, frighteningly short of fats, sugar and meat, almost completely lacking in vital

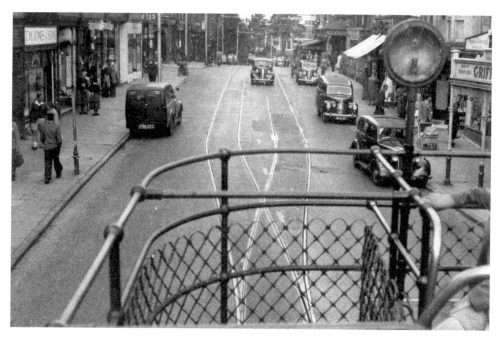

Civil Servants' Self Regard.

fruit juices and with only half a pint of milk every other day ... The average diet has undermined people's vitality.' In Merton Place the civil servants had the embarrassing task of persuading the public that all this hardship was for the best.

CIVIL SERVANTS' SELF REGARD

Margaret Whitley lived at 8 Grove Road, Colwyn Bay, and in 1942 she was nine years old. Each morning she walked to the bus stop on Abergele Road, opposite the top end of Greenfield Road (above left), where the trams turned round to return to Llandudno, to catch her bus to Conway Road School in the West End. Seventy years later (now Mrs Logan), she can still recall the indignity and unfairness of it as the Ministry of Food civil servants pushed her out of the way and made their way to the front of the queue as they squawked, 'Out of the way; we're doing vital war work. You'll have to wait for the next bus.' To young Margaret this was doubly wrong as her parents had to accommodate two Ministry of Food employees in their house at a guinea each a week. They were known to the locals as 'the guinea pigs'. Margaret, however, did like the American nurses who came to Colwyn Bay to look after the soldiers who were convalescing after returning from the raid on Dieppe. They handed out chocolate and sweets and were not in the least officious.

Some of the London civil servants may have felt self-important, but they nevertheless worked diligently for the good of their fellow countrymen. In November 1940, Mr J. Van Zwanenberg wrote from the Metropole Hotel to a Mr Wheeldon about his concerns regarding the difficulty of booking important telephone calls. He wanted to purchase 3½ million cases of oranges from Spain and he was worried about diplomatic relations. He wrote: 'I have had to ask for it (priority) on two occasions in the last three or four days and this morning after waiting two hours I have just been informed that there are still nineteen calls ahead of me.' Somehow or other, two years later, thanks to Mr Zwanenberg, Percy Roberts of Rhos-on-Sea was able to get his hands on a box of oranges which he gave to his pregnant daughter-in-law and I was born a very healthy baby.

THE AMERICAN CANTEEN

The hundreds of American soldiers who camped in Colwyn Bay while waiting for D-Day were not of course attached to the Ministry of Food and were not, therefore, allowed to fraternise with the civil servants at their 'watering holes' in the Colwyn Bay Hotel, the Metropole Hotel or the Pwllycrochan Hotel. The Americans had their own canteen which was set up in the Colwyn Bay Engineering Co. Ltd. Garage (after the war, known as Hollindrake's Garage) on Princes' Drive. It was demolished in 1984 to make way for the A55. A local man, Mr Joseph Prendeville, was invited to a meal

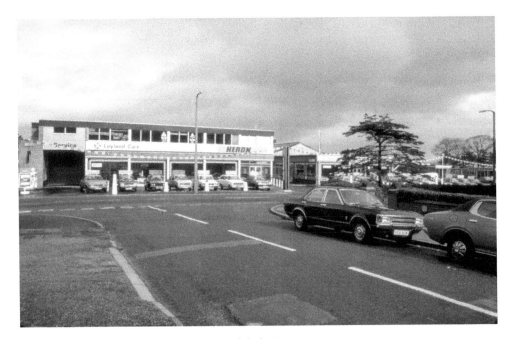

The garage in the 1970s after Heron had acquired the business.

in the canteen and could not wait to return home to report to his wife that they had been served peaches with the meat. The war led to an increase in eating outside of the home as precious ration books and coupons were not needed for eating in restaurants. By 1944, nearly 10 per cent of all food consumed in Britain was being eaten in works canteens, schools, cafés and restaurants. During the war, on Saturdays and Sundays the American troops, to the fascination of the local Colwyn Bay boys, played a foreign game, baseball, on the adjoining waste ground (now known as Prince's Park) and allowed these same kids, including Austin Stevenson, a future manager of the garage, to join in and on special days to scrounge some exotic candyfloss, the absolute tops in luxurious living. The Americans made sure that their troops, and the American people generally, were properly fed. At a time when an American's meat ration was double that of the British people, the United States Army's transportation chief contemptuously said that the British 'were still living "soft" and could easily stand further reductions'. During the war the income of the American farmer rose by 160 per cent. Everyone smiled at the phrase that the Yanks were 'oversexed, overpaid and over here'. There was also little elastic left for ladies' knickers, a consequence of the military need for rubber, which often descended. This gave rise to the joke: 'Heard about the new utility knickers? One Yank and they're off.'

A CONVIVIAL WAR TIME COMMUNITY

Everyone was in agreement: they were all playing a vital role in winning the war while at the same time they were enjoying themselves in a wonderful location, untroubled by the hell of war. The rich social and romantic life that flowered in such a small tight-knit community was exhilarating for the locals. As a school boy, in the summer holidays, Fred Davies signed on for work with the Ministry at 19/- shillings per week, forgetting to mention his age, and then at the end of the holiday he counted his earnings and went back to school. The churches were packed, everyone was employed and the schools were overflowing with pupils. In addition, the rationing system organised from Haddon Place on Lansdowne Road, which was designed to provide a balanced, healthy diet regardless of income, had the effect of producing taller and healthier children than those of the previous generation with a lower incidence of disease. There were some regrets: scarce oranges or orange juice was only available for babies, and in the run-up to the D-Day landings hundreds of American GI soldiers were based in Colwyn Bay, which prompted Hetty Harley (née Ellis), who was nine years old at the time, to complain for the following seventy years, 'I was too old for oranges and too young for Yanks.'

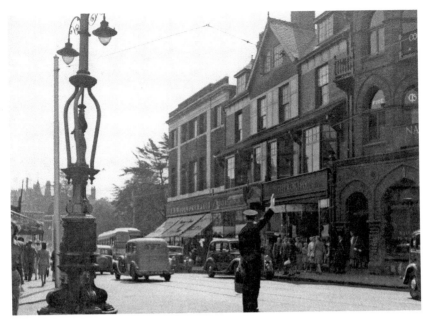

This photograph, taken from the same spot as that shown below, is the view looking towards Old Colwyn, with Woolworths on the right-hand corner. During the war there was always a policeman on duty at this spot. At night, during the blackout, if the locals came staggering out of the Central drunk, he would whack them over the head with his truncheon. Of course this never seemed to happen to the goody-two-shoes Ministry civil servants.

Summer 1943, Conway Road, with the Central on the right. The lamp remained unlit for another two years.

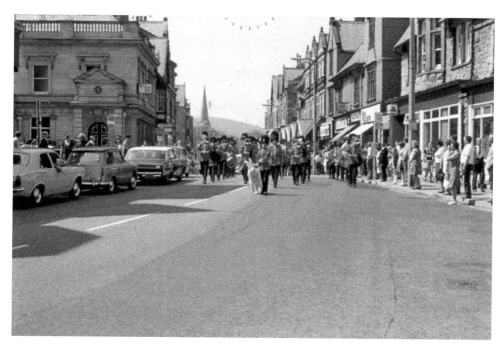

The same spot today.

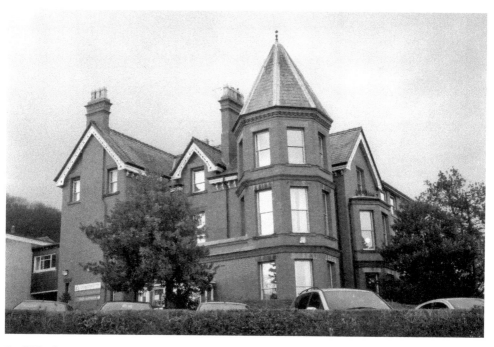

Swell Hotel.

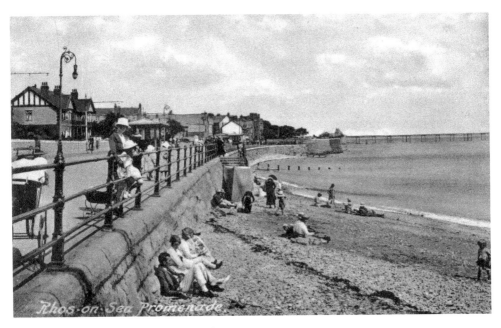

Locals in Rhos-on-Sea, *c.* 1932, enjoying the bracing air.

THE SWELL HOTEL

One of the unforeseen consequences of the civil servant invasion of Colwyn Bay was the extra beds required at the maternity hospital. Many of the Ministry officials brought their wives with them, who, invigorated by the sea air, proceeded to get pregnant. Olive and Alan Roberts had a Ministry civil servant and his wife, John and Nita, billeted in their home and after a while Olive and Nita announced to each other, at the same time, that each of them was pregnant. During the war there were a few private maternity homes such as Nurse Johnson's establishment on Watkin Avenue, Old Colwyn, but most of the babies arrived in the Maternity and Child Welfare Centre at Plas Tirion (page 31) on Nant-y-Glyn Road, which had been opened in the nick of time on 14 July 1939. It was nicknamed, by the knowing London ladies, as the 'Swell Hotel'.

THE ESTABLISHMENT DEPARTMENT

Mr B. I. Felton was in charge of this department which was run from the Colwyn Bay Hotel. Miss Moyer was the Higher Executive Officer and the eighteen-year-old Betty Tuczek was one of the many secretaries. The department was involved solely in the allocation of staff to the other departments and the consideration of promotions as staff left for other posts. When Betty left the Colwyn Bay High School in 1942 and

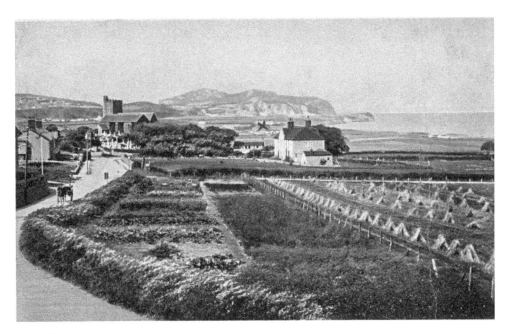

The fields where Betty Tuczek now lives.

went for the interview for an appointment in the Ministry of Food, the lady interviewer asked Betty her surname and when told it was Tuczek, replied, 'Oh, the last time I heard that name was when your father interviewed me after the First World War for a job in the Ministry of Labour.' Only ten years before Betty was born, the top end of Church Road in Rhos looked like the picture below. She now lives in a house built on the field full of bundles of corn on the right of the picture.

Llandrillo-yn-Rhos parish church, seen above, is to the left and the large vicarage to the right, with Church Road running left to right down across the fields. The churchyard is the last resting place of William Horton, who once owned most of the land around Rhos-on-Sea; he died in 1944. Also buried here is Harold Godfrey Lowe, who acted bravely and survived the sinking of the *Titanic*; he also died in 1944. Also commemorated on a headstone is Lt-Col. Frank Frere MC, who died in 1943 after being tortured by the Germans. On Thomas George Osborn's headstone, the inscription reads: 'The Founder of Rydal School'. He died in 1916. Benjamin Powell, who died in 1903, is described as 'The late Station Master Colwyn Bay'. One small plot holds the remains of an 'Unknown Sailor' whose body was found in the sea off Rhos after his ship, *The Loweswater*, sank in December 1894; the owners of the ship did not attend the inquest into the sinking for fear that they would become financially responsible for the death. Daniel Allen, who died in 1904, the founder of the Station Road department store, is buried here. Also buried in the churchyard is Tom Midgley, who died twelve years after the end of the war, aged 101, and who I remember well as a kindly, pipe-smoking gentleman.

THE MESSENGERS

John Hughes fought in the First World War and then became an RAC patrolman. As a patrolman he was given the area from Penmaenhead to Betws-y-Coed to look after and for this endeavour he was provided with a bicycle. When the Second World War began he was too old to join the army, but wanted to help the war effort, and so became a member of the Ministry of Food where he was appointed a 'Supervisory Messenger'. This job entailed organising a group of men who carried urgent secret messages and whizzed with them between various properties, such as Pwllycrochan Hotel, Rydal and Penrhos Schools, the Mount Royal and Mount Stewart Hotels, etc., inhabited by the Ministry. The only other method of communication between the departments was by telephone and that, in 1940, was unreliable and not secure. The messengers had motorbikes and a uniform with a crown on the lapel. In 1945, when the Ministry returned to Guildford, Mr Hughes, having carried out his duties with exemplary hard work, was invited to join the organisation outside London. But he and his wife decided that Colwyn Bay beat Guildford hands down; he stayed and became the Parks and Gardens Inspector with the Borough Council. Ivor Lewis, a well-known local telephone engineer, was also a Ministry dispatch rider, but he only had a bicycle. However, at the end of the war, he reckoned himself to be the fittest man in the Ministry Dispatch Department. The photograph opposite shows Mr Hughes in his RAC days, just before the war, stood at the Rhos Road and Brompton Avenue crossroads. Today, this is a busy junction with traffic lights. Mr Hughes' boss, Mr Lochnain, was a forthright Irishman with a large moustache and the pair of them did not see eye to eye.

EFFICIENCY AND SECURITY

Miss Wallace, the eighteen-year-old daughter of William Wallace, the head of the confectionary department, between leaving school and starting her university course, worked for the Ministry in Penrhos College. It was her job to 'chase 3/2s', to hurry on certain special forms from one department to another, no doubt from time to time using John Hughes and his 'messenger' colleagues. Every night duplicates of particularly important documents were strapped into a large parcel inside a waterproof cover and taken elsewhere by a member of staff to cover the possibility of the College building being bombed in the night. On one particular evening this unwieldy object was given to Miss Wallace to transport to a safe house and to be returned in the morning. Unfortunately, she travelled five miles to and from work by bicycle from Tan-yr-Allt Hall in Llanddulas. In the morning, when she was returning the precious documents, it was raining and in the centre of Colwyn Bay her bicycle wheel caught in a tramline. She skidded and the weight of the parcel on one handlebar shot her across the road to land at the feet of a bemused policeman who picked her up and sent her on her way. Meanwhile her father, William Wallace, who had endless meetings in Colwyn

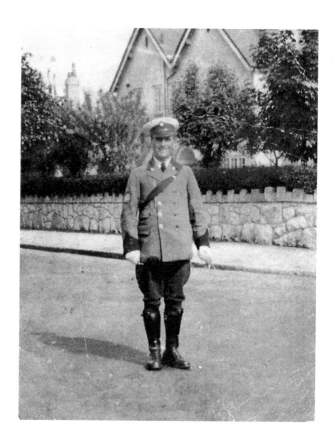

Right: Mr Hughes, the Messenger.

Below: As Miss Wallace would have seen it during the war, Victoria Avenue, leading from Greenfield Road to the station, and under the railway line (on the right) down to the promenade.

Bay, Chester and London, was drafting answers to Parliamentary questions as well as answering a letter from a ten-year-old boy about the supply of sweets. His difficulty was that he was precluded from giving any full or free answers. For twelve months he had to answer questions about consumer rationing of confectionery by saying that the matter was being taken in 'full consideration' when he had already decided how it was to be done. When sweet rationing came, it was announced not by Mr Wallace, nor by Lord Woolton, the Minister of Food, but by Winston Churchill himself.

THE EDELWEISS BREAD DIVISION

The hotel had originally been built as a private residence called Twr Eirias and in the early twentieth century it became home to the Dinglewood School. In 1913, the National Vegetarian Society held its month long summer school in the building and between the two World Wars it was transformed into a hotel. In April 1942, a Mr P. H. Artiss, a market gardener, was quoted as saying, 'Goodbye white bread until peace returns'. White bread was thought to be a patriotic alternative to Germany's 'barbaric' loaf of rye, and it mysteriously fell off the back of many a lorry. It was from the Edelweiss Hotel off Lawson Road (demolished in 2010) that the effort was directed to maintain a supply of bread for everyone. The Ministry of Food motto during the war was: 'We not only cope, we care'. There was no cynicism or 'spin' in that aspiration, it was true. The Ministry also advertised a slogan: 'Medals for Housewives', and declared, 'The British Housewife is helping to make a second front – the Kitchen Front – against Hitler. That is why we say, Medals for you Madam.'

RATIONING

Sixty-four years after the war ended, Terence Frisby recalled in his autobiography, *Kisses on a Postcard*, the time when as a nine-year-old evacuee, along with his seven-year-old brother, in Doublebois, Cornwall, he was given a pasty as a treat, which tasted only of potato and pepper; it had never seen meat. All over the country farmers were fattening cattle; they had to obtain a permit before they could kill a pig or a cow. All this was the consequence of decisions made in the Colwyn Bay Hotel. Lord Woolton's civil servants could sometimes go too far and on one occasion Churchill dictated a letter to Lord Woolton on the absurdity of excessive food rationing. 'Almost all the food faddists I have ever known,' he wrote, 'nut-eaters and the like, have died young after a long period of senile decay. The British soldier is far more likely to be right than the scientists. All he cares about is beef.' Churchill's letter ended, 'The way to lose the war is to try to force the British public into a diet of milk, oatmeal, potatoes, etc.,

The most pleasantly situated Hotel in Colwyn Bay

AA APPROVED

EDELWEISS HOTEL

LAWSON ROAD COLWYN BAY

LICENSED TELEPHONES: OFFICE 2314 GUESTS 2338

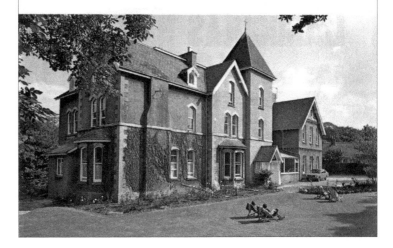

The Edelweiss Hotel.

Twr Eirias (The Edelweiss), 1904, was later transformed into the building above and which is shown being demolished in the picture below. All the employees of the Ministry of Food pulled together to 'get the job done'. Incredibly, it had only been two years earlier in 1937 that parties of German boys, Hitler Youth members, had swapped their black caps with British children while stopping at Rydal School. One Rydal boy described the visitors as 'a jolly good crowd of chaps'.

The Edelweiss Hotel being demolished.

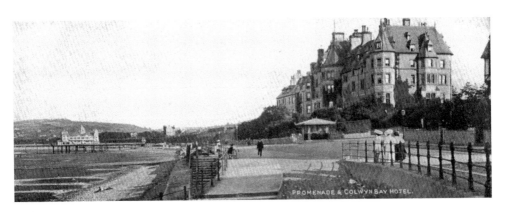

Rationing.

washed down on gala occasions with a little lime juice.' However, rationing helped to break down class distinctions. With a Duke getting the same food entitlement as a docker, a truly democratic spirit started to infuse the country, all made possible by decisions made in the hotels and schools of Colwyn Bay.

With rationing came the problem of queuing. Evidently ladies spent 15 to 20 minutes queuing at shops during the war and the Ministry of Food was not very keen on this because it thought the static lines of disgruntled, weary, gossiping women engendered 'hot beds of discontent' from where all sorts of rumours would spread like wildfire! It was understood by the civil servants that the distribution of scarce items could not easily be controlled and one unrealistic Ministry official, lurking in the depths of one of our local hotels, even suggested that queues containing more than a certain number should be banned. Fortunately, this authoritarian suggestion was never implemented. One wartime husband was heard to say, 'I don't queue, my wife does that'. In a Mass Observation report from Derby in 1940 it was reported: 'Due to repeated raids, many people go shopping in quick dashes.' That, of course, was not the case in Colwyn Bay.

Although a young teenager, Eric Spotswood certainly dashed about on his paper-round before going to school. His workload had soared with the arrival of the civil servants from the Ministry as he cycled between all the Ministry of Food premises delivering all sorts of newspapers, which before the war he had never heard of. Eric's parents were also a little harassed as they had agreed to look after twenty-three evacuees from Liverpool in their home, Warwick House, 43 Abergele Road.

ST JOHN'S METHODIST CHURCH

On a Sunday evening, after the service, there was always entertainment for the soldiers that were stationed in Colwyn Bay and so a lot of the young Ministry of Food civil servants and typists also went along. They had to sit through the religious service and were not allowed to stay for the food after the entertainment, but it was nevertheless rewarding to see a free show in an age before television, especially on a Sunday in Wales. The very best act, which Audrey Andrew still remembers seventy years later, was the man who played the saw. St John's Church is now part of Rydal Penrhos School, as sadly over the intervening year's church attendance has fallen drastically, making it financially impossible for the Methodist Foundation to maintain the building any longer. Perhaps they should have stuck with the after-service variety shows. Audrey Andrew's home was in Crosby, Liverpool, but after it had taken five hours for her to travel there by train one Saturday, because the train ran out of coal at Chester, she gave up going home at the weekends.

These privations and simple pleasures were nevertheless part and parcel of the vital job of making sure that the British people did not go hungry. Evelyn McKendrick in Southampton recalls that it 'was surprising what you could do with 6 ox meat, 4 oz

St John's Methodist Church.

cheese, 2 oz butter and one precious fresh egg a week'. When it was someone's birthday they would either save their rations to make a cake or 'bake a carrot cake with carrots from your own garden plot'. Evelyn had a friend who was a grocer and now and again he would leave an illicit banana outside her door. 'They tasted amazing simply because they were such a luxury'.

CEREAL PRODUCTS DIVISION

This division started life in the large dining room of the Mount Stewart Hotel. There were thirty-six young ladies, including the seventeen-year-old school leaver Joyce Lumley Davies, hammering away at very antiquated typing machines and their first job was to make a list of every flour mill and every bakery in Great Britain. None of the ladies took dictation so they had to rely on the appalling writing of their boss, Mr Farquherson. They all worked till late in the evening and until 1.00 p.m. on Saturdays. In 1943, the department moved to the newly-built government buildings on Dinerth Road where, to stop the din of the typing, in order to give the typists their instructions, Miss Shepherd, the supervisor, with a metal ruler, used to wallop the metal lampshade hanging above her desk. There was one Irish lady, Miss West (known as Westie), who was considerably older than the rest of the girls and was a little hard of hearing, never

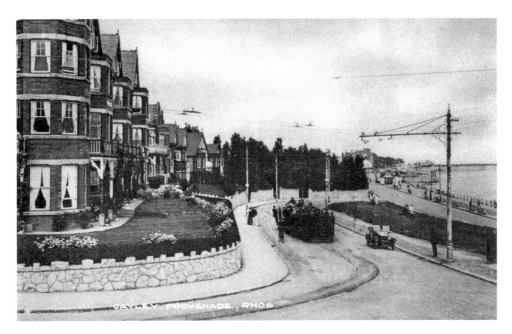

Mount Stewart Hotel, *c.* 1936.

heard the lampshade clang, and so always got into trouble when she continued to type, much to the delight of all the other ladies. The man in charge was Mr Law, who owned a large flour mill, Crawford & Law, and whose home was in the tiny Scottish village of Rhu on the shore of Gare Loch. Mr Law looked exactly like Anthony Eden and was once mistaken for him while walking along the promenade. He wore expensive clothes, a homburg hat, had excellent manners and smoked cigars. The typing ladies loved to be told to go into his office because they adored the smell of his cigars and they were always offered a sweet.

The Mount Stewart Hotel was run by Walter Howarth, a member of the Colwyn Urban District Council, seen in the left-hand corner, and a 'toast rack' (a single-decker, open-topped tram) can be seen heading for Rhos. Jack Simms, when on leave from the army, used to play the drums in the Bob Allen three-piece band (or two-piece if the organisers weren't flush that particular week). His favourite venue was the Mount Stewart Hotel because there was a tram stop right outside the hotel and he could fit all his drum kit, at no extra cost, behind where the driver sat. He saved all the money he earned on his leaves, half a crown an hour, and at the end of the war he bought himself a Hammond Organ.

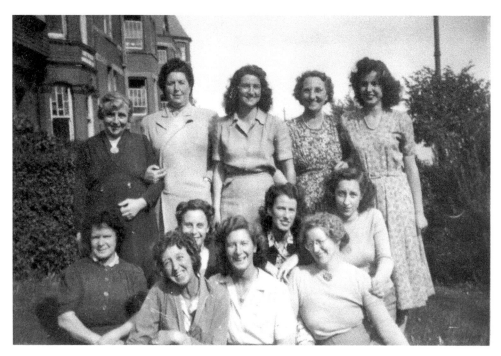

The typists on the lawn outside The Mount Stewart. Kay Watson is stood in the centre and Megan is in the middle of the second row with her hands on the shoulder of the lady in the front.

BACON AND HAM DIVISION

This department was also run from the Mount Stewart Hotel after it had been moved from the Colwyn Bay Hotel. A London civil servant, Henry Turner, was in charge with the assistance of Miss Moyer who appointed Miss Kay Watson to look after all the lady typists. Mr Turner asked Kay to become his personal secretary, but she wouldn't leave 'her typists'. After the war and after having been engaged to three other men, Kay married Jack Newton who owned the fruit and vegetable shop on Everard Road in Rhos-on-Sea. Kay had started her time with the Ministry as a lodger in an apartment on the Upper Promenade where she and the other lodgers had lettuce with every meal and on a Saturday she would cycle to Capel Curig for a poached egg as this was where the black market flourished. The typists came from as far afield as Holyhead and Holywell, and in the winter Kay would have a roaring fire ready for them in the hotel lounge and they would be given a hearty breakfast before being told , 'now you can jolly well get on with your work for the rest of the day'. One of the girls who lived on a farm on Anglesey used to bring in a fruitcake to share with the other typists, which was a secret luxury. Kay's best typist was Megan Roberts who had been trained in the Norfolk House Hotel and who in later life, as Megan Conwy, recalled her time in the Metropole as 'lovely, idyllic'. There were five butcher's shops in Rhos-on-Sea during the war, Billy Howe (Rhos Road), Syd Cutler (Everard Road), Jack Kitchen (Church Road), John Pierce (Colwyn Avenue), and Billy Roberts (Penrhyn Avenue). Megan was

Billy's daughter. One girl, Iris (later to become Mrs Mathews), who had an excellent singing voice, used to practice her repertoire as she typed.

FREDERICK MARQUIS, 1ST EARL OF WOOLTON

During the vital years from 1940 to 1943, Lord Woolton was the Minister of Food. His organisational skills and his strong personal popularity were instrumental in maintaining a steady flow of wholesome food to the British people. He spent quite a lot of time shuttling between his office in London and his headquarters in the Colwyn Bay Hotel. However, he never stayed in Colwyn Bay; he always made a point of staying in the Station Hotel in Llandudno Junction, known locally as 'The Killer' because railway workers went there to kill time. He arranged, as had Lady Erskine eighty years earlier, to have his own railway halt beside the Colwyn Bay Hotel where he would alight with great pomp. Indeed, even if he had wished to do so, he could not have stayed overnight in Colwyn Bay because his officials had requisitioned all the hotels as offices. In the 1930s he had built up the department store Lewis' (not to be confused with the John Lewis department stores), of which he became Managing Director. The draper became the nation's wartime grocer. Geoffrey Dawson described him as 'a cheerful cove'; an attribute which may well have contributed to his success as an inspired administrator while directing the operations of 40,000 people handling the national rationing and distribution system. He was very good at explaining himself and his aspirations to the

A train travelling from Colwyn Bay, passing Penrhos College on the left, on its way to Llandudno Junction.

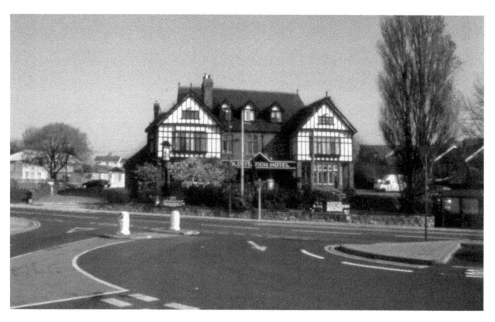

'The Killer' in 2011, the wartime refuge of Lord Woolton.

nation over the wireless. The 'Woolton pie' made with cheap, nutritious and available ingredients became a staple food for many people throughout the land. He was a member of Churchill's inner circle, but the two men did not always agree. In November 1942, the Prime Minister discovered that Lord Woolton had banned the exchange of rationed food and wrote expressing a view still relevant in the twenty-first century.

> I hope it is not true that we are enforcing a whole set of vexatious regulations of this kind. It is absolutely contrary to logic and good sense that a person may not give away or exchange his rations with someone who at the moment he feels has a greater need. It strikes at neighbourliness and friendship. I should be so sorry to see the great work you have done spoilt by allowing these officials, whose interests are so deeply involved in magnifying their functions and their numbers, to lead you to strike a false note.

No doubt some of these self-important officials were skulking, hidden away in the Colwyn Bay Hotel. At the end of 1943, having established the success of the Ministry of Food, Lord Woolton handed over the reins of the Ministry to John Llewillin, and he was appointed to a new office, as the Minister of Reconstruction. In later years he became an Earl and a Viscount and died on 14 December 1964 aged eighty-one years. Twenty-three years earlier in Colwyn Bay, in the middle of the war, he had asked one of the young Ministry clerks, Mrs Gwladys Jones, what she felt was the most essential foodstuff desired by the British housewife, she replied, 'A tea bag Sir'.

A FRISSON OF OPPOSING VIEWS

Lord Woolton, a public relations genius, who strove only to ensure that the British consumer was as happy as the food supply would allow, had as colleagues in the Ministry, Bob Hudson, the Minister of Agriculture, and Tom Williams as his Parliamentary Secretary. The trouble was that Bob Hudson, a man fanatically determined to get his own way, was not too bothered about the customer; all he worried about was the welfare of the farmer, so there was an inevitable tension within the department, exacerbated by the different personalities of the Lord and of Bob. Lord Woolton was patient, clever and courteous. Bob Hudson was rude and quick tempered. Mr Hudson was also partially deaf and if his boss won an argument, which he invariably did, Mr Hudson was not above taking advantage of the defect, going away and doing exactly what he said he would, ignoring the fact that their discussions and conclusions were, of course, circulated within the department in written form. At the end of the day, however, Lord Woolton had two great advantages, his flair for public relations and the aid he could ask, and get, from the United States of America. However, the British farmer loved Bob Hudson, while the civil servants, Eirwen Jones, Peggy Boden, Ken Dibble, Joan Bellis, Cec Owens, Elizabeth Tuczek, Laurette Prendeville and all the rest, working away in peaceful contentment in the Colwyn Bay Hotels, simply shrugged their shoulders and got on with their work.

THE SEWING FACTORY

Many of the male civil servants serving with the Ministry of Food arrived in Colwyn Bay without their wives. Girlfriends and partners did not live with men in those days and so these men, being of their time, were unable to darn their own socks or mend the holes in their trousers and jackets; they had no one to perform these tasks for them. Instead they hurried along to Mr A. P. Bibby, who owned the sewing factory in the old tin building on Coed Pella Road. Mr Bibby employed eighteen ladies to carry out this invaluable war work and they are pictured overleaf, outside the tin building which has now been demolished to make way for the car park behind the D.S.S.

THE MEADOW CROFT HOTEL ANIMAL FEEDING STUFFS DIVISION

The Meadowcroft on Llannerch Road East (seen on page 48 in 1940) was owned by Stan and Hestor Barlow, who in 1940 were told that they and their two young children had 48 hours to leave and find new accommodation. The hotel had forty-two rooms and some of the residents were infirm, so the Barlows were confronted

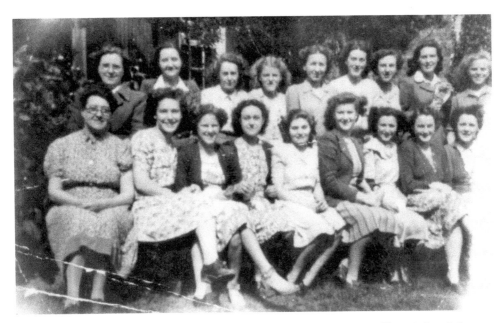

Back row l-r: Nellie; Annie from Old Colwyn; Margaret Hughes; Joyce Spencer-Williams (whose father was one of fifteen children and whose mother was one of ten); Nellie from Tan-y-Wal; Gladys from Llysfaen; Phyllis; Josie Parr; Barbara Williams, who was an evacuee and after her Colwyn Bay boyfriend dumped her she returned to Liverpool from where she had come. Front row l-r: Miss Harrison, who was forever eating sweets and never offered them to anyone else; Blodwen Roberts; Gwyneth Jones; Betty; a lady from Dolgarog; Elvina; Betty Price; a lady from Tal-y-Bont; Vera Williams.

Coed Pella Road during the war with the Sewing Factory and its tin roof on the right of the picture.

The same spot, *c.* 1985, showing the highly regarded policeman, Roger Skinner, directing the Mayor's Parade.

with an enormous task. All the hotel's fixtures and fittings were carted away and stored in Rydal School for the duration of the war and when in 1946 Mr Barlow reclaimed this stuff only half of it could be found, to the extent that they could only furnish half of the hotel rooms. Most of the tables had cigarette marks on them and a lot of the linen ended up in hotels in Llandudno. Mr Barlow was a little put out that although he and his family had been given only 48 hours to leave the hotel, it then remained empty for the next nine months while their former porter became the property watchman. In 1941, the civil servants of the Animal Feeding Stuffs Division moved in. The whole operation was given over to making sure that the animals of Great Britain had enough to eat. Miss Muriel Davies (later to become Mrs Hughes) worked in the statistics department working out how much of commodities, such as hay and turnips, were required by farms of differing sizes from John O'Groats to Lands' End. Top statisticians, one of whom was a Miss Nichols, were drafted in from London. Major Bremner, who in peacetime ran the British Oil & Coke Mills (BOCM) Co., was in charge, along with Ainsley D. Fairclough, who had a firm which manufactured cattle food, as did his colleague James Bibby. Ken and Elsie Wheatcroft arrived in Colwyn Bay in 1942, whereupon Ken went to work in the Inland Revenue in Llandudno and Elsie, because she had children of school age and so was obliged to work, was drafted into the Animal Feeding Stuffs Division. Joyce, their teenage daughter, who had been in an all-girls' school in London, where she was taught by ladies, was thrown into the mixed Eirias High School where she discovered

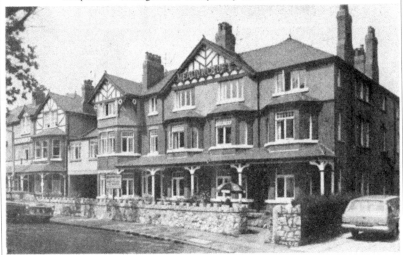

MEADOWCROFT
RHOS-ON-SEA
"WHERE CHILDREN ARE WELCOME"
Telephone:—Management: Colwyn Bay 48375. Guests: 48374

FULLY LICENSED BAR FOR RESIDENTS
Ideally situated in quiet surroundings yet close to safe, sandy beach. Near Puppet Theatre
and Bathing Pool.

The Meadowcroft Hotel is on the left and the Silver Howe Hotel is on the right, which was used as a sanatorium for officers. Penrhos School was on the right-hand side of the road.

The same road today with a housing estate behind the trees on the right.

schoolmasters for the first time. These schoolmasters did not sit behind their desks but on top of them and did not hand out books individually to the pupils but threw them at them. However, she thrived and discovered that she was better taught in Colwyn Bay than she had been in London. One of the delights of working in the Meadowcroft was that it was just across the road from Penrhos College, where Elsie and her Ministry of Food friends, such as the young Ken Dibble, who was fresh out of school, would go at lunch time to the excellent canteen for a leisurely meal. The Meadowcroft reopened for business in 1946 in time for the National Eisteffordd, which was held in Eirias Park.

Rationing did not come to a complete end until 1954 when both the people of Britain and the animals were allowed to eat what they could find and holidaymakers staying in the Meadow Croft Hotel were served a restricted diet but not one prescribed by officials of the Ministry of Food.

Early in the war, the ten-year-old Dick Watson was cycling along a quiet road in Newbury, Berkshire, when a large army lorry full of American soldiers overtook him. One of the soldiers, riding in the back of the lorry, saw him and tossed out an orange to him, which he caught; an act of impulsive generosity which Dick has never forgotten and which has endeared him to Americans ever since. All restrictions concerning food were thought out and controlled from Colwyn Bay which even had an effect on a ten-year-old lad cycling along behind American servicemen in another part of the country.

COLWYN BAY HOTEL MINISTRY OF FOOD HEADQUARTERS

When Lord Woolton was in town this was where he was based, as was his Permanent Secretary, Sir Henry French. Realising that a war was probably inevitable in 1938, the government had formed a Food Defence Plan and united all the different Marketing Boards under the one roof of the newly-formed Ministry of Food. Mr John Corbet, a leading Liverpool accountant, was based in the hotel and so was the Communication Division, led by John Jenner and Vic Groves, where all the coding and decoding of cables was carried out. As soon as all the civil servants were able to get down to work everyone agreed with the relief expressed by the Ministry of Food driver, Harris Carter, who, when Mr and Mrs William Llewelyn of the Woodlands, Old Colwyn, expressed concern at the outcome of the war, said, 'Don't worry, we're on our own now and we'll do a lot better. We'll be alright.' Between February and April 1943, there was no electricity in the hotel between the hours of 9 a.m. to 12 p.m. and 2 p.m. to 4 p.m. However, the civil servants were allowed to have small coal fires in their rooms, many of which used to be the hotel bedrooms.

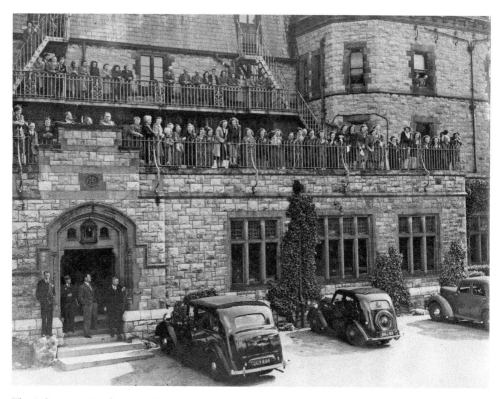

The Colwyn Bay Hotel remained under the control of the Ministry of Food until 1953 when it was eventually handed back to the owners who proceeded to reopen it for business the following year. In the photograph above, the staff have come out to get a glimpse of the new Queen Elizabeth passing in the Royal Train. Vic Groves is stood in the middle on the front step.

COCOA AND CHOCOLATE (WARTIME) ASSOCIATION (DEPARTMENT)

There was a ditty during the war which ran:

> Food obtained
> By methods shifty
> Is shared with Hitler
> Fifty – fifty.

During the war people could have done without sweets and chocolates but it was felt that the Ministry of Food should make an effort, under the departments leadership of William Wallace the Deputy Chairman of Rowntrees, working in the Colwyn Bay Hotel, to ensure that everybody, and especially children, were able to have a few of the luxury end items of the food market. What the department was really doing was rationing the meagre supply of confectionary that was available. Lord Woolton, known affectionately as 'Lord Fred', believed that the public should be educated and helped,

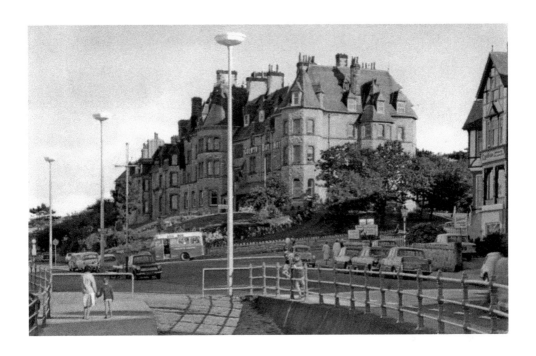

The Colwyn Bay Hotel, above in the early 1970s and below as it is seen today. Many people tried to save the building from being demolished but to no avail. It was designed by John Douglas, who also designed St Paul's and St David's Churches, Colwyn Bay; St John's Church, Old Colwyn; Christ Church, Bryn-y-Maen; and the Colwyn Bay and Bryn-y-Maen vicarages.

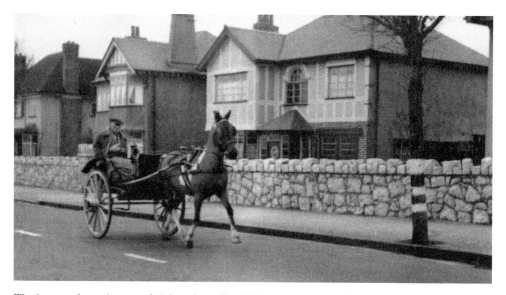

Wartime travel, trotting passed Oakroyd, number 75 Brompton Avenue, Rhos-on-Sea. Fortunately, due to the excellent and efficient distribution of scarce food throughout the British Isles, organised from the hotels and schools of Colwyn Bay, this horse was more fortunate than its Italian counterpart.

not just instructed and the effort to supply children with sweets was an example of this dictum. Mr Wallace realised that people with sufficient time were able to chase the restricted amounts, while munitions and other workers were kept, by long factory hours, from getting a fair share. The 'Personal Points' Scheme, allowing everyone an equal share, was approved by Winston Churchill and introduced in the Spring of 1942 when he announced that 'children must have their sweets'. Yet these were delicacies beyond the dreams of the people of the occupied countries across the English Channel. At the end of the Italian campaign Major Keith Rae backed a horse at Milan racecourse which died of exhaustion during the race, whereupon the crowd, who had seen little meat for some time, swarmed on to the course, leaving the jockey with only his saddle and bridle – and a skeleton.

WEDDING BELLS AND WAR

Samuel Beckett said 'the tears of the world are a constant quantity'. From 1939 to 1945 the killing elsewhere shifted the emphasis of Beckett's idea across to the other side of the English Channel, while here in Colwyn Bay the war and the creation of the Ministry of Food ensured a season of happiness and friendly comradeship. Olive and Alan, pictured on the following page, were married on 16 May 1940 at the Congregational Church in Rhos-on-Sea, across the road from the Ministry's Rhos

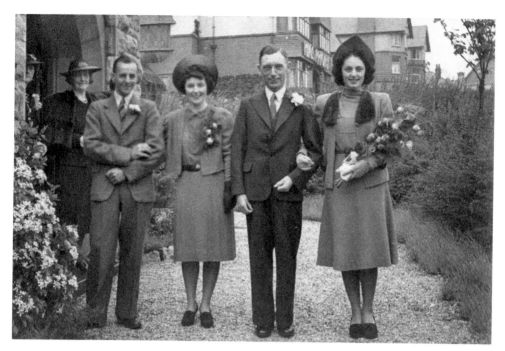

Olive and Alan's wedding day, 16 May 1940.

The Congregational Church in Rhos-on-Sea today.

Priory Rest and Recreation Department. At the same time British troops were fighting for their lives in France, including Olive's brother, John. Eight days after the wedding thousands of these soldiers were evacuated from the beaches of Dunkirk. On the left of the wedding party is Billy Marsden, who within the year was to be killed flying on a bombing raid over Germany. His valour is commemorated on the war memorial at Applethwaite in the Lake District.

THE ENGLISH BUTCHER

As a young man, Albert Rigby worked in the local Information Office and was able to help the Ministry of Food clerks, who had arrived in their droves and had no idea where to find all the vital services and food outlets. The arrival of these officials from London provided many work opportunities and prospects for Colwyn Bay residents far beyond anything they could have imagined before the war began. Albert was able to point the Londoners in the direction of the businesses which could best provide for their needs. One such fortunate business was Cutler's Butchers in the West End of town. Mr and Mrs Cutler advertised themselves as being 'English Butchers'. These

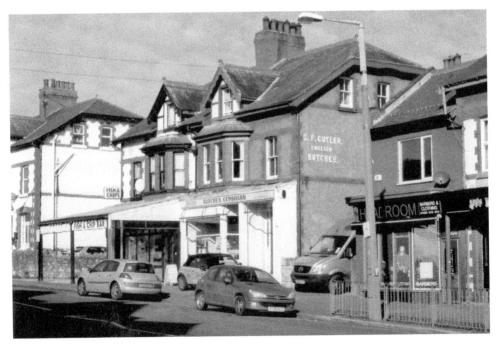

Cutler's shop today, still showing the 'English Butcher' sign in white letters on the side of the wall.

words are still plain for all to see on the side of their premises. Were that to be the slogan used today the business would possibly be prosecuted under a race relations regulation! In 1939 it was considered a mark of true quality. Although they found it increasingly difficult to find the meat to sell, they still found that they were rushed off their feet. Rabbits were also sold and would be brought round the back of the shop by men who had caught them up in the woods of Bryn-y-Maen. Mr & Mrs Cutler's son, Sydney, who had been born on the chopping block in the shop, was in the army. He was marching amongst the sand dunes at Dunkirk, trying to form some sort of order amongst the troops when a German plane flew overhead and randomly began machine gunning any one the pilot could see; Sydney dived into a hole and found his brother, Ray, and Quinton Hazel already in the hole preparing breakfast. When the war was over Sydney returned home and continued the family business but I always wondered whether the customers knew about the chopping block.

A GRAND STAND VIEW

Between September 1940 and May 1941 the Germans systematically and clinically bombed the cities of Britain. More than half the deaths, 23,000 out of a total of 43,000, occurred outside London, with almost two thirds of the buildings destroyed. One

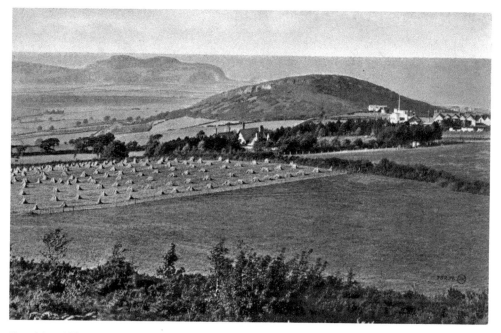

Grand Stand View.

evening in 1941, Gwilym Pritchard and a friend went down to the promenade to watch the bombs fall on Liverpool. They stood there in silence transfixed as they saw the fires burning and the flashes of the explosions across the waters of Liverpool Bay. On Saturday 3 June 1944, George Walsh, a Conway Road Council school boy, was on the golf course in Upper Colwyn Bay (which is now covered by a housing estate with roads named after famous golf courses) with his father, Frank, when he saw the horizon from Liverpool to Anglesey filled with a mass of ships. He remarked to his father that something must be up and three days later they heard about the landings in Normandy. Jim Robinson, an evacuee from Liverpool, was taken up Snowdon and still remembered, seventy years later, the red glow in the distant sky as his home town burned after a German raid; yet curiously, as a twelve-year-old boy, he never recalls feeling concerned for the welfare of his parents. As a teenager, Derek Bellis (the brother of Joan from the Ration Book Department) stood with his father on the summit of Bryn Euryn and saw the battered shipping convoys on the horizon limping their way back into Liverpool harbour.

The picture on the previous page shows Bryn Euryn from Copthorn Road, Upper Colwyn Bay. To help ensure the safety of the local population and more especially the smooth running of the Ministry of Food, the Home Guard and local soldiers, awaiting news of their postings, were detailed to keep watch from the summit of Bryn Euryn for enemy shipping and airplanes. There was a Radio Location Beam on the summit which emitted radio beams on to which airmen would take a bearing at the same time as they were taking a bearing from the beams from the beacons on Llysfaen hill and the Great Orme, thus enabling them to pin-point their own position. 1n 1940, a small concrete room was built on the summit in which the men could shelter. Almost 2,000 years earlier the Romans had also stood there.

THE LOCKYER'S PRIVATE HOTEL ADMINISTRATION CENTRE

The civil servants working here, in the old Lockyer's Hotel on Marine Road in Colwyn Bay (a building which still exists and is now called Marine Court, shown below), just up the road from the main headquarters in the Colwyn Bay Hotel, were involved in the coordination of all the differing strands of the Ministry's work. The man in charge was Mr Banks Amery. He was related to the influential political Amery family. Leo Amery was the High Commissioner in India and had, with a powerful speech in the House of Commons, been instrumental in the downfall of Neville Chamberlain; Leo's son was John Amery the traitor, who broadcast from Germany and was eventually, at the end of the war, arrested in Italy by a young British Officer, Captain Alan Whicker, the future TV broadcaster. Mr Banks Amery would travel back to London fairly regularly to liaise with Lord Woolton and on his return he would invariably bring a delicious bag of chocolates for one of his young clerks, the nineteen-year-old Olive Roberts. This was an amazing gift in the middle of a war and the bag was soon empty. Unfortunately, Mr Amery's secretary

Lockyer's Hotel.

was an absolute harridan, sarcastic and manipulative (perhaps she didn't receive any chocolates), and several clerks had already left before Olive also asked for a transfer, foregoing the delight of the scrumptious chocolates. Mr Banks Amery became Head of the British Food Mission and in September 1943 was in Australia trying to persuade the Australian Government to send extra vegetables to Britain. By this time Olive was the mother of a six-month-old baby boy and had left the Ministry of Food for good.

A ditty, thought up in one of these Colwyn Bay establishments to encourage the British housewife:

Little cubes of carrot / Leeks and 'taters too / Simmered with some Bovril / Make a beefy stew.

The Ministry produced an advertisement:

Thousands of Women, aged 17–50 Wanted, To Become Cooks, in The ATS and WAAF.

They needed the ladies because all the men were otherwise occupied, far from home, fighting the Germans and the Japanese.

Geoff Jones (fully recovered in 1980) and his proud wife Jean, outside their home in Maes-y-Fron.

LORD HAW HAW AND GEOFF JONES

Geoff Jones, a resident of Colwyn Bay and a soldier in the Royal Welch Fusiliers, was captured by the Germans outside Caen in 1943. After this catastrophe, his opinion of General Montgomery was forever afterwards mischievously and colourfully expressed. Geoff's wife, Jean, heard nothing from him and had no idea whether he was dead or alive; that was, until one summer's day when she was sat on a wall in Park Road in Colwyn Bay chatting to a group of friends, listening and laughing at the voice of Lord Haw Haw on the wireless. This was the sarcastic nickname given to William Joyce, the British fascist traitor and collaborator, who used to broadcast items from Germany which he felt were subversive to British morale. On this particular afternoon, while Jean and her friends were listening, Lord Haw Haw triumphantly announced that the Germans had captured a number of Welsh soldiers and proceeded to name them. One of them was Geoff. Little did Lord Haw Haw realise that this news, rather than being greeted with despondency, brought unmitigated relief and joy to Jean, who now knew that her husband was alive and safe. She promptly feinted, fell off the wall, and had to be carried inside the Park Road house to recover. The Germans made Geoff and his comrades walk across France and Germany into Poland. He was made to work in the mines and then as the Russians approached from the East, he was marched westwards until they met the

Americans. When he eventually arrived back on Colwyn Bay railway station, he was so thin and haggard that Jean walked straight passed him. Jean's powers of observation and Montgomery's tactical flair were themes Geoff returned to many times.

THE HADDON PLACE RATION BOOK OFFICE

Before 1939 the relationship between food and war had never been made quite so explicit. Rationing made every meal a step on the road to victory. Sir John Bodinnar was in charge at Haddon Place (below, before the war) where it was his job to ensure the speedy distribution of Ration Books all over the country. The poor fellow was surrounded by young lady clerks, typists and telephonists, most of whom had only just left school. One recent school leaver was Joan Bellis (later to become Mrs Sattler) who used to enjoy the thrill of being telephoned by Army Generals who would announce that they had two thousand soldiers arriving at a camp somewhere in southern England

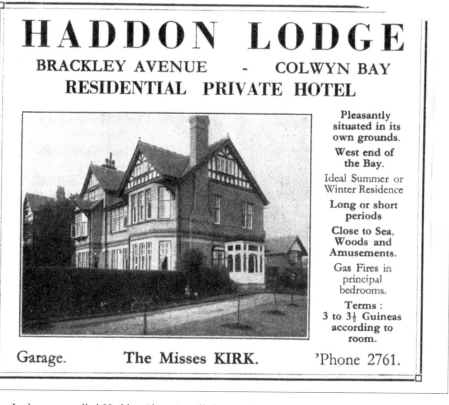

HADDON LODGE
BRACKLEY AVENUE - COLWYN BAY
RESIDENTIAL PRIVATE HOTEL

Pleasantly situated in its own grounds.

West end of the Bay.

Ideal Summer or Winter Residence

Long or short periods

Close to Sea, Woods and Amusements.

Gas Fires in principal bedrooms.

Terms : 3 to 3½ Guineas according to room.

Garage. **The Misses KIRK.** 'Phone 2761.

Haddon Lodge, now called Haddon Place, is still there today on the corner of Brackley Avenue and Lansdowne Road. It has now been split up into apartments, but retains its air of permanence.

who needed ration books within two days. Joan, or one of her colleagues, would listen to the order, tell the General to hold the line for a few moments and put the receiver down on the desk, then, keeping the general waiting, the young ladies would have a little natter after which Joan would pick up the receiver, put it to her ear again and coolly tell the General that the books would be at the camp on the day requested. After the war Miss Bellis became a very successful and well liked teacher at the Conway Road, West End, Primary School. The ration books were kept in the government warehouse beside the Black Cat roundabout where the roads streak off to Glan Conwy, Conwy, Llandudno Junction and Llandudno. It was also here that the Ministry kept a huge store of butter which arrived from dairies all over the country, as well as sunflower oil, sugar and salt. Secrecy surrounded the announcement of any commodity that was to be rationed for the first time to try to prevent a rush to purchase and hoard. Everyone had four coupons to 'spend' on toilet soap, hard soap, washing powder or soapflakes, for a four week period.

THE LEGAL & ENFORCEMENT DEPARTMENT IN THE ELLESMERE HOTEL

Today, the hotel building on the corner of Ellesmere Road and Conway Road is used by a department of the Social Services which specialises in the needs of old people, the physically disabled and the sensory impaired. In 1939 the hotel was run by Mr and Mrs R. T. W. Allen, but they were told to find somewhere else to live and the civil servants moved in. It was from here that a team of inspectors would tour the country randomly visiting farms to check if food fit for human consumption was being fed to livestock instead. If the inspectors found flour, etc., in animal food bins, the hapless farmer was prosecuted, and the clerks in the Ellesmere Hotel would prepare the papers and instructions to prosecute. Margaret Lloyd was sixteen in 1940, and she was the Personal Assistant to the Head of Animal Foodstuffs and she would often find herself liaising with the Enforcement Department. She had followed her father from Liverpool who was also in the Ministry of Food, but she had been advised, initially, to join the Ministry in London and then be transferred to Colwyn Bay because that was more financially rewarding than being summarily evacuated to the town.

THE POTATO DIVISION IN THE PWLLYCROCHAN HOTEL

This was the pre-war Potato Marketing Board which during the war was simply a sub-division of the Ministry of Food. The civil servants loved working in the old hotel with its beautiful views and excellent canteen. On his demob towards the end of the war,

The Ellesmere Hotel, between the two World Wars, before the Allens took over.

The building as it looks today.

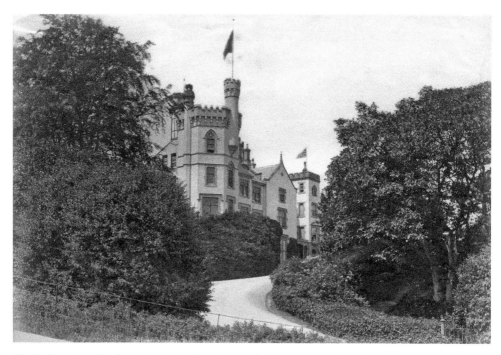

The Pwllycrochan Hotel in its heyday before the arrival of the Ministry of Food.

The hotel building today in 2011 surrounded by the Pwllycrochan Woods. It now houses Rydal Penrhos Junior School.

Four years before the war and four years before the school was turfed out of its buildings by the Ministry of Food, the school celebrated its Golden Jubilee with a gymnastic display on 'Top Field'. This field, between, Pwllycrochan Avenue and Queen's Drive has now been made perfectly flat.

James Leven from Montrose, Scotland, had joined the Board and was asked whether he would prefer to serve his time in Guildford or Colwyn Bay. He said he would like to go to Colwyn Bay and so was sent to Guildford. Happily, many years later, his son married Dorothy, a girl from Colwyn Bay, and they held their wedding reception in the Colwyn Bay Hotel, the wartime headquarters of the Ministry of Food.

To make the most efficient use of land, arable farming was given precedence over the rearing of animals. An acre of grazing produced enough meat to feed one to two people. An acre used for wheat fed twenty or forty if sown with potatoes. Only cows were ever bred in large numbers to meet the increased need for milk.

In the 1940s Marguerite Patten was what today would be called a 'celebratory chef', a term she hated. The Ministry of Food employed her to advise people on how to make the most of their meagre rations. Her great value to the Ministry was that she taught people to be thrifty and not to waste valuable food. She became very well known during the war as, over the wireless on the programme, *Kitchen Front*, and by visiting markets, hospitals and workers' canteens, where she gave advice and demonstrations on the clever use of spam and powdered eggs. She educated the British housewife on

the ingenious concoctions that could be made with leftovers and in so doing made the job of the officials in the Pwllycrochan Hotel that much easier. She was the queen of economy and of making do. She is still alive, aged ninety-five, and was honoured with the CBE in 2010 and still insists in calling herself 'a home economist'.

AN EDUCATIONAL HEADACHE

With the arrival of 4,000 Ministry of Food civil servants came many of their children, which meant that overnight all the local schools became over crowded. The only way of dealing with this problem was to restrict these new arrivals to half a day's education, which to the delight of the local children meant they only went to school for the other half of the day. A Rhos-on-Sea school boy, George Walsh, discovered that most of his teachers were of retirement age and were absolutely hopeless at controlling the class. The knock on effect was that many of the small private schools did very well. Lyndon Junior School in Grosvenor Road, West End, which had been founded by Miss Anthony, initially with eight children, only six years before the war began, found that

Royal National Eisteddfod, 1946.

in 1941 the total school roll was 250. Joyce Lumley Davies, one of the pupils at the time, remembers that when the school roll had reached 100, Miss Anthony splashed out and bought all the pupils an iced bun. To mark the silver jubilee of the school in 1958 Miss Anthony unveiled a beautiful stained glass window in St Andrew's Church on Lansdowne Road, just round the corner from the school. That the school prospered was due in no small measure to Hitler's war.

One year after the war ended the Royal National Eisteddfod was held in Colwyn Bay. The picture shows the opening procession going past the pier. Amongst the watching crowd there were many Ministry of Food civil servants. The Ministry was so entrenched in Colwyn Bay, and it was such an administrative headache to relocate all the workers back to Guildford and to untangle all the various food departments that had been brought together under the one roof in 1939, that it was not until 1953 when the last remnants of the Ministry departed. Some of the civil servants had discovered that living in Colwyn Bay was more pleasurable than living in the hurly-burly of London and some had married local ladies and so they decided to stay. It was said that after 1945 there was a surfeit of bowler hats in Colwyn Bay as the London civil servants, who had arrived five years earlier with this headgear wedged firmly on their heads, returned south leaving them behind.

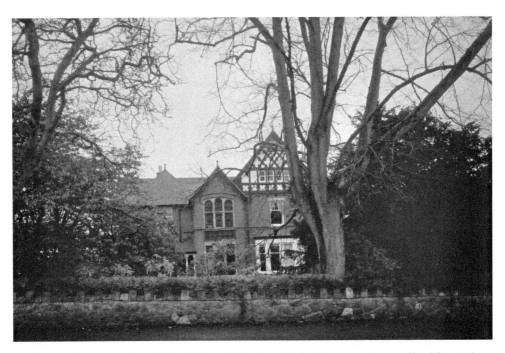

Brooklands after Mr O'Brian, Skiddy, Skilly and Olive had all left. Olive spent the rest of her life in Colwyn Bay but the other three went back to Guildford when the Ministry of Food returned there in 1946.

THE BROOKLANDS CATERING DIVISION

Brooklands is a large house on Brackley Avenue, Colwyn Bay (No. 34), which at the beginning of the war was owned by Mrs Pollitt. However, the house was requisitioned by the Ministry of Food in 1940 and poor Mrs Pollitt was turfed out. Olive Roberts arrived from the Lockyers Hotel Administrative Centre to find that her new boss was Mr Brian O'Brian, a hard and unrelenting taskmaster, described by one of the young secretaries as a 'sour bachelor'. He would say things like 'don't you lot realise that there is a war on, you will stay here until all the day's work is complete'. Olive well remembers one civil servant, Mr Sidwell, an accountant, who worked at Brooklands and had arrived from London with his wife and children, sighing with exasperation one evening, 'I'm off, it's my wedding anniversary today and I'm blowed if I'm staying here any longer.' As a nineteen year old, this act of defiance seventy years ago impressed Olive! Mr Sidwell and another accountant in the department, Mr Skilton, were referred to by a flighty young typist as Siddy and Skilly. It was from Brooklands that the staff arranged for the safe delivery of food to all sorts of catering establishments, army barracks, police stations, works canteens, munitions factories and cafés and restaurants all over the British Isles. The most numerous of the cafés were the Lyons Corner Houses, where at the beginning of the war it was estimated that of the 7,600 waitresses (or 'nippies' as they were known), 800 to 900 of them would marry customers each year.

LOCAL DEFENCE LEAGUE

This was the original name given to the Home Guard (shown opposite practicing ferrying a wounded colleague across a local river). All the members of the Ministry of Food had to be either fire watchers at night or join the Home Guard. What happened of course was that all the men joined the Home Guard, which left all the ladies to keep an eye out at night time for falling bombs and the consequent fires. Neither set of people saw any action at all. F Company, which was part of the 1st Battalion Denbighshire Home Guard, was led by the three men who were in charge of the Ministry Animal Feeding Stuffs Division, Major Bremner, Ainsley Fairclough and James Bibby. During the night time they would sometimes bed down on the Penrhos College tennis courts, which was where Kenneth Dibble nearly had his head blown off by one of his Home Guard colleagues who accidently discharged his weapon with five cartridges, leaving a gaping hole in the wall just above Ken's head. Indeed, the Home Guard remains, uniquely, the only large force in military history ever to have inflicted more casualties on its own side than on the enemy, while at the same time blasting off at stray livestock, suspicious scarecrows and hapless motorists who failed to stop at roadblocks.

Members of the Home Guard practicing ferrying a wounded colleague across a local river.

A Lewis Gun Section – 'B' Company.

SERGEANT TWN NOS A BORE

There was a prisoner of war camp at Tal-y-Bont and one at Llangwstenin for captured Italian soldiers. One of the Welsh guards who looked after the prisoners at Llangwstenin was known affectionately as Twm nos a bore (Twm night and day) for the simple reason that he escorted the prisoners back to camp at night time after completing their work in Mochdre, and roused them from their huts in the morning to take them back to work again at daybreak. The Italians understandably never wanted to escape and their work consisted mainly of clearing the stones and rubble from the river running through Mochdre, which was promptly filled up again at night by the young lads from the village.

POLICE WAR RESERVISTS

The senior police officers and young constables all went off to fight for King and Country which left the local police force full of part-time volunteers with a smattering of older experienced sergeants. Leonard Firth, a local draper (and a future mayor of Colwyn Bay), the owner of what was locally and affectionately called the Remnant Shop on the corner of Abergele Road and Meirion Gardens, was appointed a Police War Reservist. He and his colleagues were given a list of hotels (such as the Tan-y-Bryn Hotel on Tan-y-Bryn Road, seen on page 70) and apartments and were told to go and clear them of the holiday makers and visitors and close them down for the arrival of the civil servants attached to the Ministry of Food. Mr Firth went to Gronant on Sea

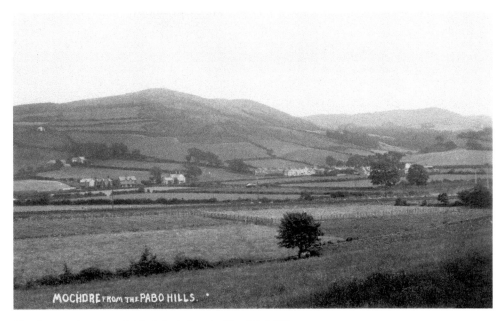

The river running through Mochdre before the First World War.

Wern Crescent, Mochdre, in 1943.

The Tan-y-Bryn Hotel on Tan-y-Bryn Road.

The same spot today as the picture above.

View Road, which was run by Mrs Sherrett and Mrs Shufflebotham, and told them that they had twenty-four hours in which to clear the premises of all the residents. Mrs Sherrett never patronised the Remnant Shop ever again.

A BATTLE FOUGHT FROM COLWYN BAY

In 1804 Admiral Lord Nelson wrote, 'I consider the protection of our trade the most essential service that can be performed.' As many as 30,248 British merchant seamen lost their lives bringing food and other vital supplies to the United Kingdom between 1939–45. It was from Colwyn Bay that the battle to feed the population of these islands was fought in an effort to reduce the deaths of our sailors. In 1941, Lord Woolton said: 'This is a food war. Every extra row of vegetables in allotments saves shipping. The battle of the Kitchen front cannot be won without help from the kitchen garden.' Eating potatoes instead of bread could save the lives of sailors on the ships that brought grain across the Atlantic. A year after the war ended Egon Ronay, who in later years was to produce his guides to the best restaurants, was appalled by the dismal standards of service in British restaurants and the British attitude to food and dining. When he ordered a cup of tea at the buffet at Victoria station and asked for a spoon, the waitress

The wartime allotments on East Parade, still being used in the 1970s just before this road was obliterated by the A55. The railway station is in the background and the pier on the right.

pointed dismissively to a single teaspoon hanging on a piece of string attached to the ceiling. However, what did he expect after six years of scrimping and saving, rationing and blackouts. He was jolly lucky there was a spoon. Sixty-six years after the war ended, the author Michael Frayn, writing about his father, recalled the kitchen garden at their home in which his father grew tomatoes, apples, blackcurrants, raspberrys, runner beans, potatoes, carrots, cabbages and curly kale. A wonderful effort, which would have made Lord Woolton smile and possibly helped to save the lives of our merchant seamen. In a Christmas radio broadcast in 1942 Lord Woolton said: 'I ask you when you sit down to dinner, do one thing – all of you, pause for a moment and pray God may preserve all those men of high valour who go down to the sea in ships and who have brought you so much of your food this year. We owe them more than our prayers.'

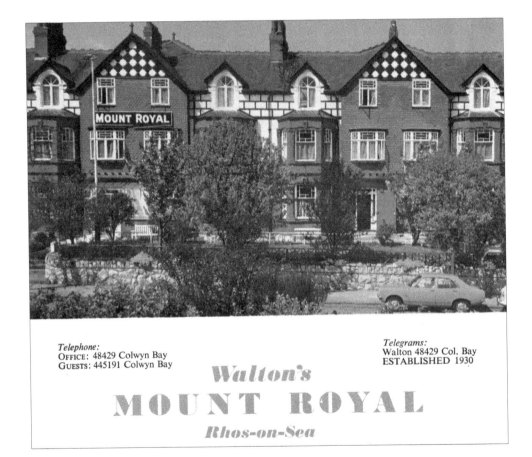

Telephone:
OFFICE: 48429 Colwyn Bay
GUESTS: 445191 Colwyn Bay

Telegrams:
Walton 48429 Col. Bay
ESTABLISHED 1930

Walton's

MOUNT ROYAL

Rhos-on-Sea

The Mount Royal Hotel in Rhos-on-Sea.

WELFARE FOODS DIVISION

This department, in the Mount Royal Hotel in Rhos-on-Sea, was wholly involved in the distribution of milk, cod-liver oil and orange juice. These drinks were considered vital to the well-being of the British people although most of the milk was powdered, the cod-liver oil tasted awful and the orange juice was so diluted as to be almost useless. Mr John Bradbury was in charge (later to become Lord Bradbury on his father's death in 1950) and Peggy Boden had been moved from the War Time Meals Division as his Executive Officer. There were two 'run around girls' in the department who evidently both made an unsuccessful play for Mr Bradbury's affections. Peggy was given the task of drafting answers for the Minister of Food to deliver in the House of Lords in response to Members questions. The department issued a little homily for the British people: 'Grow fit, not fat on you war diet'. William Wallace, who was in charge of the Confectionary Department, and was living in the quarry owners house, Tan-yr-allt Hall in Llanddulas, adhered strictly to this advice, always finishing his simple evening meal with brown bread and an apple. One third of the specially recruited private citizens, such as Peggy Boden and William Wallace, some of whom had been brought back from retirement, died or became totally incapacitated as time went on through sheer pressure of work.

THE QUEEN OF THAILAND GOES SHOPPING

Queen Rambhai Barni and her husband HM King Prajadhipok of Thailand and their daughter, nicknamed by the locals as Peaches, were staying at a hotel in Llandudno. They had found themselves stranded in Britain by the war. The Queen became a regular customer of Frank Little's shop (following page) owned since the 1920s by George Bower, at the bottom of Station Road. The delicious smells and aromas of the shop reminded the Queen and her daughter of their own exotic country. In 1941 the royal party moved to Virginia Water for the sake of the King's health; he died there and eight years later Mr Bower's oriental customer took her husband's ashes back to the Grand Palace of Thailand where they were buried. Another customer who Mr Bower looked after was Mrs Partington. She was the widow of the founder of Manchester United Football Club and still owned the centre circle of the pitch at Old Trafford. She used to arrive at the shop in her blue Rolls-Royce driven by her chauffeur at the most drastic and critical points in the war, as though she was oblivious of the fact that a war was being fought. Little's was a shop which was run exquisitely well and sold only the best coffee, tea, etc. What with Queens, Manchester United owners and Ministry of Food employees reared in London, Mr Bower had a very good and interesting war.

The shop where the Queen of Thailand went 70 years ago, when George Bower reigned supreme.

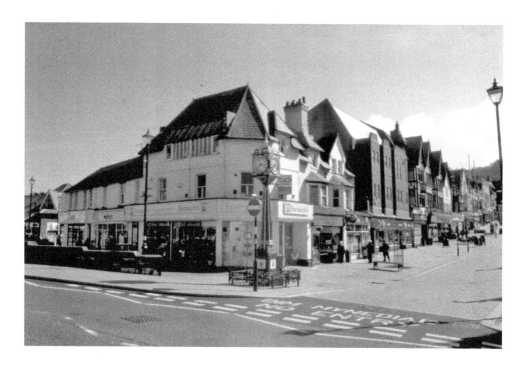

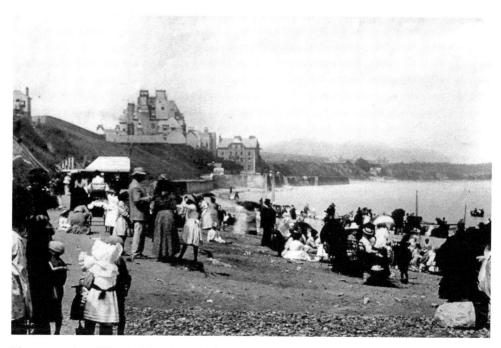

The promenade, *c.* 1880, the leisurely world that was swept away by the two World Wars.

NINO'S

In 1942, Vic Groves reported to Mr Bury at the Mount Stewart Hotel where he was appointed the Executive Officer in the Cereals Finance Division. He had two male and four female civil servants to help him vet the travelling claims of sundry inspectors of flour mills and storage depots all over the country, and that was the sum total of their work. There were only about forty of these inspectors and so it worked out that on most days they had one claim to vet. Claims were only submitted once a month when all they had to do was to check up on the mileage claimed against the allowances per mile and pass the form to the Finance Department for payment. Their only check on mileage was an old AA road atlas. It is not surprising, therefore, that the normal day was made up of opening the mail in which there would perhaps be two claims at the most, deciding whose turn it was to check these, then proceed to do the crosswords in the daily papers, after which they would decamp to Nino's for coffee. Nino's restaurant on the promenade at Rhos-on-Sea is still there today and is now run by Mr A. C. Cerefice I.C.V., the son of the original owners who served Vic Groves and his colleagues during the war. One of the homilies thought up by the Ministry of Food and produced in the newspapers was: 'British housewives can command Victory by their Salvage efforts. Be British to the bone and save your Bones,' but I don't think Vic and his colleagues thought much of that.

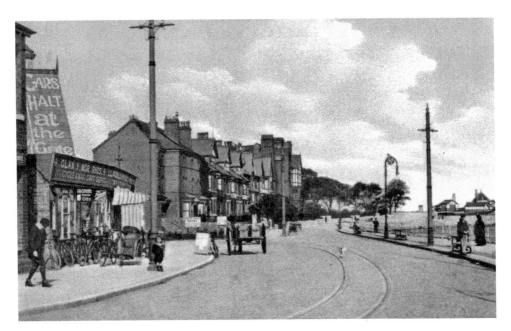

Rhos-on-Sea just before the First World War, with the tram track curving round into Penrhyn Avenue, which was originally called Tranway Avenue. Today, Nino's is situated where the red and white blinds can be seen on the shop on the left. The business began in a tiny shop on Rhos Road which was constructed between two larger buildings (now Ambrosia Tea Rooms to the left and the Shoe Box to the right) and is now part of the Shoe Box.

The original Nino's building (on the same site as the present business) which between 1952 and 1958 Mr Cerefice leased to his sister-in-law, Mrs Forte, hence the name on the building.

Nino's, seen here in January 2011, is the thriving hub of the community.

WAR TIME MEALS DIVISION

The Division was housed in the Queens Hotel, Old Colwyn, and was concerned with meals on wheels and more importantly with making absolutely certain that the Queen's Messenger Convoys, which were motorised canteens positioned all over the country, were ready at a moment's notice to go to any emergency in a badly bombed area, and that they were properly stocked. So on 15 November 1940, the day after the raid on Coventry, after which one resident wrote, 'I don't see why we should be afraid now, for there is nothing left for them to bomb', the Queen's Messenger Convoys were trundling around the city distributing food. The man in charge in the Queen's Hotel was Sir William Bertram Chrimes CBE. He was the Managing Director of Coopers of Liverpool, a large grocery store on the main street of that city. He was affectionately known as 'The Chief' and was a forward thinking, charitable and kindly man. It was his idea to put aside one penny for every £1 that his workers earned, allowing them to save for holidays and for health care. Sir William had a twenty-seven-year-old daughter, Eileen, who had married a Colwyn Bay doctor, Dr Henry Davies, with whom Sir William stayed in Old Colwyn. His Executive Officer was Miss Peggy Boden, who had arrived in Colwyn Bay with her uncle, William Russell, and his wife, after his stationary business in Liverpool had been burnt to a cinder by German incendiary bombs. Peggy was described by the seventeen-year-old Betty Tuczek as 'wonderfully efficient'. To help her, Peggy had a Grade Two Clerk or as Peggy describes her 'a run around girl'. Due to the appalling severity of the bombing, the workload was so heavy for the staff in the Queen's Hotel that the civil servants in the Pwllycrochan Hotel were also roped in to help with making sure that

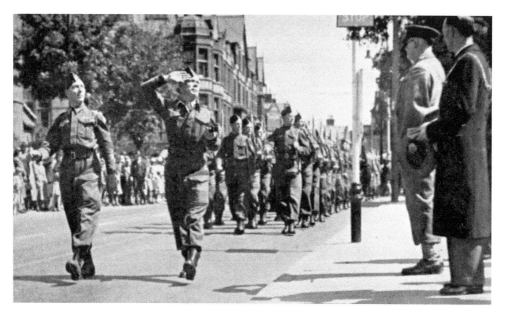

The Denbighshire Home Guard taking salute outside the Town Hall.

the food convoys were maintained. After the raid on Coventry, the King visited the city to see for himself the Queen's Messenger Convoys that Sir William, Peggy and the 'run around girls' had organised. The King, advised that all the food shops had been bombed, offered to bring his own sandwiches. Instead, Lord Dudley, who was accompanying the King, sent his butler over with a cold lunch from Frimley Hall.

LOVE IN THE QUEEN'S HOTEL

In 1940 Alan Patrick Kift, a forty three year old Londoner, arrived in Colwyn Bay as a civil servant to work in the Ministry of Food. He was sent to the Queen's Hotel. There he met Esyllt Wen Williams a twenty seven year old Welsh lady from Rhos Farm, Capel Curig. He could not speak a word of Welsh but by the end of the war they were married, had a son, Vincent, and were living in a small apartment on Rhos-on-Sea Promenade. In 1945 Alan whisked his young bride and baby son back to London. The farming gene must have remained in the family because some years later Vincent ran a farm in Betws-y-Coed and Vincent's daughter became a gardener. Esyllt's brother, Jack Williams, became a shepherd for Lord Mostyn on the Great Orme and remained there for the rest of his life at Pyllau Farm. Esyllt was a clever lady and was fortunate in that her father paid for her to attend the Pitman School in Menai Bridge, where she learnt to type, which allowed her to join the Ministry of Food where in consequence she met her future husband and set sail on her subsequent life. The war and the Ministry of

Food had piquant personal ramifications throwing people together from unusually different backgrounds, a fact which Alan and Esyllt never regretted.

FOOD EXPERIMENTS IN THE COLWYN BAY HOTEL KITCHENS

In 1941, Lord Woolton arranged for a cookery book, *Food Facts for the Kitchen Front*, to be produced and in the introduction he wrote: 'I should not care to present a copy of this book to the ghost of Mrs Beeton. That generous phantom would no doubt be shocked by the simplicity of the recipes given here.' I am sure he was right. As an example, one of the recipes was 'Brains on toast', with the instruction: 'Wash the brains well in salted water, tie in muslin, and boil in salted water for about 10 minutes. Cut into neat pieces, put on toast and cover with parsley sauce.' All the recipes in the book

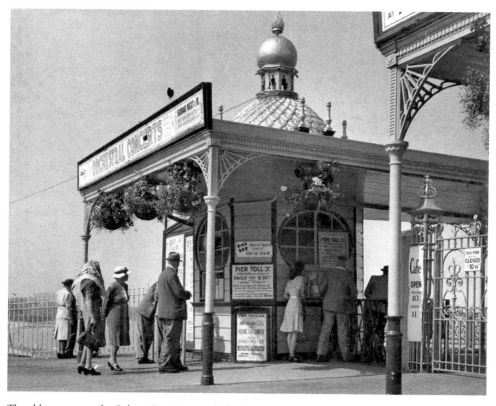

The old entrance to the Colwyn Bay Pier on which the locals and the Ministry officials enjoyed the wartime dances and entertainment. When the two booking offices were built in 1900 they were described as being designed in the 'moorish style'. This lovely ornate entrance survived Hitler's mines but could not survive the ravages of the peace which followed.

were devised and tested in the kitchens of the Colwyn Bay Hotel, once renowned for top-quality cuisine. To conserve gas and electricity the book advised housewives to equip themselves with a hay box oven, made from an old packing case or tin box, lined with newspapers, and filled with clean hay made from grass chippings, in which nests were made to hold saucepans of partly cooked food.

However, at this time everyone was experimenting. Alice Worth (née Williams) recalls that the homemade stuffing her mother made at Christmas 1941 was 'better than any meal I have ever tasted since'. If they were lucky they would also get a tin of fruit from Joe Cheshire the grocer.

THE BLACK MARKET

At the end of 1943 the Ministry of Food estimated that food stocks had risen by almost 400,000 tons compared with the beginning of the year, and were someone to twelve million tons above the minimum safe levels for the time of the year. However, this in no way satisfied the residents of Colwyn Bay, the very spot from where the food supply was being organised. The locals were surrounded by small farms in the local lush, undulating countryside; in Llanelian, Llysfaen, Bryn-y-Maen, Rhyd-y-Foel, Dolwen, Dolwd, Betws-yn-Rhos, Llangwstenin and Mochre the farmers were only too ready to earn a little pocket money by selling their produce without expecting coupons in return

The ideal black market country, behind Llysfaen looking towards Betws-yn-Rhos, from Trawscoed Road. Down in Rhos-on-Sea one afternoon in 1942, Mrs Marshall announced to her family that she was going to make an eggless cake, news which her family thought was hilarious as she already had a cupboard full of clandestine eggs ready for secret consumption.

Bryn Person, Llanelian, *c.* 1915. The very sort of place which would have been visited 70 years ago, without the knowledge of officious Ministry of Food snoopers, to the mutual advantage of the farmer and the Colwyn Bay visitor.

Bryn Person as it is today in 2011.

and the local constabulary were thin on the ground anyway. Two farms in Llanelian, Bryn Person (now known affectionately as Tom Turf's Place, as he sells turf), and Bron Heulog, on the opposite corner to the church, were happy to sell their surplus food to the locals and even to some brave Ministry civil servants. The Ministry issued one of its numerous 'Food Facts': 'Never leave food uncovered. The thick dust which settles after a blast due to a bomb explosion frequently renders food unfit to be eaten.' A piece of information lost amongst the lanes and hedgerows of Colwyn Bay's hinterland. The ladies would often disregard the official sanctions on food rationing, as some of them, as well as drawing lines up the backs of their bare legs to simulate stocking seams, would fake-tan their legs with onions and Oxo cubes.

THE MOUNT ROYAL TEA DIVISION

The hotel on Whitehall Road, Rhos-on-Sea, was just along the road from the busier Ministry establishment, the Mount Stewart Hotel. Mrs H. Thomas, the owner of the hotel, found herself the host to the Ministry Tea Department in 1940 and watched while this vital British brew was distributed around the country. One of the clerks was a lady called Lilly Jane Owens, who had already done her stint towards a war effort as she had helped to manufacture munitions in Dundee during the First World War. The building has now been converted into flats. Many people found the meagre

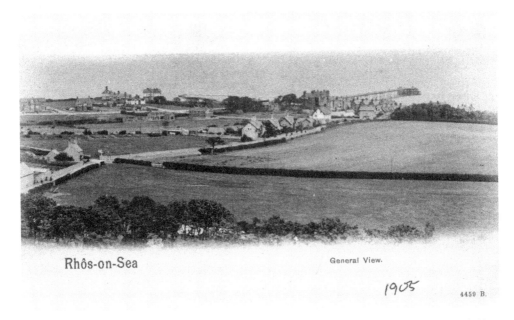

Rhôs-on-Sea General View.

1905 4459 B.

Rhos-on-Sea in 1905 before the Mount Royal was built. The hedge running left to right across the fields is the present line taken by Brompton Avenue.

rations, especially the 113 grams of meat, boring, and sometimes complained. When Winston Churchill heard about this attitude he asked to see the ration list and declared it would be quite enough for him. What he had not quite twigged though, was that the 4 ounces had to last you the whole week, not just one day. Churchill of course could always afford to eat out. Restaurants, oddly enough, were not subject to rationing. It was in the Mount Royal that the idea was conceived to produce a propaganda map entitled 'Tea Revives the World', which was printed in 1940 in gaudy, brilliant colours. There was a word of caution to the Tea Division from Professor Lindeman, Churchill's leading scientific advisor, about excessive rationing quotas. 'It is the only luxury of the working woman, whose morale should not be jeopardized,' he wrote.

In 1943, thirty-eight years after the previous photograph was taken, two Red Cross nurses, Miss Duffy and Mary Sangster, were billeted with Mrs Williams and her nine-year-old daughter Alice at Starnhill, Pendorlan Avenue. Their job, along with their colleagues, Connie, Charlotte and Jane, was to arrange social events and entertainments for the soldiers billeted in Colwyn Bay. Much to Alice's delight they were also able to snaffle chewing gum, chocolate and peanut butter and bring it home for her to eat. Mary was an exceptionally talented pianist who had an Army lieutenant friend who had sung with Bing Crosby prior to joining the army. She also had a boyfriend called Lieutenant Bill Knapp, known to Alice and her friends as Knappy, who called at Starnhill with his jeep and driver, impressing not only Mary but also the young Alice. Alice's elder sister, Doris, joined the Auxiliary Fire Service, but her father forbade her to wear the trousers issued with her uniform.

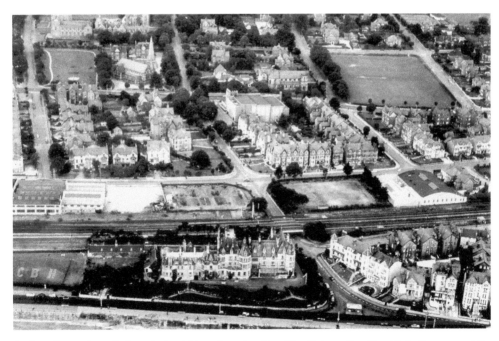

A pigeon's eye view of where it should have been heading. The Colwyn Bay Hotel is in the centre at the bottom of the picture. The large building in the centre at the top is the Odeon Cinema and the large low lying building on the right is the American Canteen in Holingdrake's Garage.

PIGEON POST SERVICE

The original head of the Communications Division at the Colwyn Bay Hotel was Sir William Goode. He had worried about what would happen to the efficiency of his Division if the Germans had invaded the east coast, marched westwards across the country, and cut the north off from the south. How would the two halves communicate? Apparently he had never heard of wireless so he came up with the marvellous idea of pigeons. A pigeon fancier from Yorkshire was engaged at a large salary to be an Officer in Charge, Pigeon Post. A pigeon loft was planned and built by the Ministry of Works at each of the 19 Divisional Food Offices around the country plus the various headquarters in London, Cardiff and Colwyn Bay, where trained pigeons were installed. Arrangements were made for the Animal Feeding Stuffs Division in the Meadowcroft Hotel to supply the necessary corn to feed the birds and in late November 1940 Sir William was able to inform the Lord Woolton that the Pigeon Post Section was up and flying. Sir William decided to test the efficiency of the arrangements and duly sent off a pigeon from the Portman Court headquarters in London with a Christmas greeting to the staff in Colwyn Bay. The bird turned up at the loft on the roof of the Colwyn Bay Hotel in March 1941 with the message still attached to its leg. The officer in charge of pigeons at Colwyn Bay immediately sent off a teleprinter message announcing the safe arrival of the greeting message and stated that, in his humble opinion, on route the bird had met a member of the opposite sex, had mated, produced a family, and having successfully done this had continued its travels arriving at its destination precisely four months after setting off. The pigeon postal service did not last long.

THE CELTIC GLEN SICK BAY

During the war many of the Ministry of Food personnel at the regional centres such as Cardiff, and especially London, became ill or were injured and required some rest and attention. A Ministry of Food Sick Bay was set up for these people in Colwyn Bay, well away from the ever present noise and trauma of the conflict found in the large cities. There was also some anxiety about the spread of venereal disease and the government ran a reassuring campaign, the posters for which were put up in places like the Celtic Glen Sick Bay, declaring 'VD CAN BE CURED'. The posters appeared at the same time as the Co-operative Society was launching a major advertising campaign for their groceries. Their slogan was 'I GOT IT AT THE CO-OP'. The posters sometimes appeared side by side. The Celtic Glen, a former boarding house in Ellesmere Road, was requisitioned and Joyce Lumley Davies was brought from the Meat and Livestock Division where she had landed up after serving in the Cereal Product Division, to assist the Matron in all her secretarial duties. The men arrived by train (when the cost of the journey from London was £2 19s 10d) where they were met by Joyce and the Matron and transferred by limousine to the clinic where they must have imagined they had arrived in paradise.

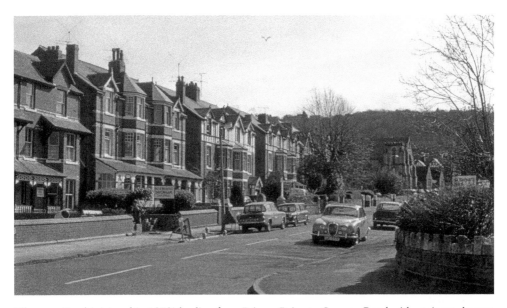

Ellesmere Road (pictured in 1978) leading from Princes Drive to Conway Road with, as it was known during the war, the Celtic Glen, on the left, with the veranda behind the small trees. It was owned by Robert Williams, who before the war had rented the rooms out as holiday apartments.

In 1942 the Ministry issued guidance from which those resting in the Celtic Glen no doubt benefited.

> Vegetables are most 'fruitful' of Vitamin C when you serve them raw … And by the way, the dark outer leaves of vegetables are richer in vitamins and minerals than the paler insides. So when they're too tough to eat raw, or to cook in the ordinary way, be sure to put them into soups and stews.

They also implored everyone to eat at least one salad each day.

THE SECRET BBC STUDIO

The authorities were worried that if the German invasion was successful the British Broadcasting Corporation would no longer be able to do its job from London. It was, therefore, decided to set up clandestine news centres in the regions; the largest of which was in the Cotswolds at Wood Norton House. There was one in Bangor and one was set up in Colwyn Bay on the second floor of 5 Penrhyn Buildings above Bruce's fruit and vegetable shop. A soundproofed control room was built which was linked to other transmitters all over Britain and was maintained to good order throughout the war. There was a wonderful camaraderie amongst the men working in the news centre,

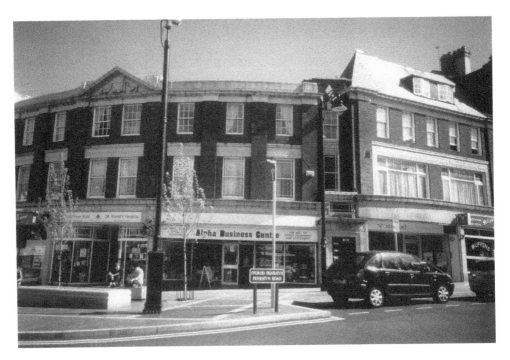

The secret BBC radio station.

some of whom had fought valiantly in the First World War, including two brothers, both of whom had won the Military Cross, one with the bar and one without. The latter acquired the sobriquet of 'The Coward'. The Studio was on the first floor of the building immediately behind the car on the right of the picture above. After the war these rooms were used by the Lantern Café.

Directly opposite the BBC Studio was the Metropole Hotel which was being used by the Ministry of Food. In the old ball room was a small shop, which was more like a tuck shop, and was run by the Peter Merchant Catering company. From here they sold cigarettes, pipe tobacco, a few sweets and ever fewer biscuits and such like. Eirwen Jones (née Hughes) used to travel from Llanddulas every day on the bus, to serve from this shop in the ballroom, from 5.00 p.m. to 8.00 p.m. for which she received £14 each week. The 'day girl' was Olwen Flavell (née Evans) and the manageress was Miss Margaret Jones from Rhyd-y-Foel, who had been trained as a caterer in the Richmond Wesleyan College. All the shops in the town closed at 5.00 p.m. so Eirwen was busy in the evenings when the civil servants would come in to buy the vital cigarettes or more often just for a chat, because the tuck shop became very much a meeting place where the civil servants, working in the surrounding hotels, could exchange news and make social arrangements for the next day.

Ezekiel Cubbon on Greenfield Road and the same spot (below) today.

EZEKIEL

A number of local builders were given the task of converting the various hotels and schools so that they could be used as offices by the Ministry of Food. Ezekiel Cubbon of Erw Wen Road was handed the task of transforming the Colwyn Bay Hotel. Ekie, as he was known to everyone in Colwyn Bay, was his own man, not a rough diamond exactly but certainly one to cherish with caution. He was in the hotel one day after the civil servants had arrived when he strode into one of the offices with his paint spray gun in his hand. The Ministry of Food official, whose office it was, shouted at him that he should always knock before entering and that he was to get out at once. Ekie turned on his heels and waited outside the door in the corridor until the official eventually came out of the office, whereupon Ekie promptly sprayed him up and down over his London suite. He went on to employ three other workmen, a bricklayer called Ephraim, a plumber called Zachariah and one with red hair nicknamed Jack Cochin.

THE RAILINGS DISAPPEAR

One of the few physical evidences of the war were the missing wrought-iron gates and railings from private houses, parks and churches, which on the instructions of Mr Beaverbrook, the war time Minister of Aircraft Production, had been torn down to

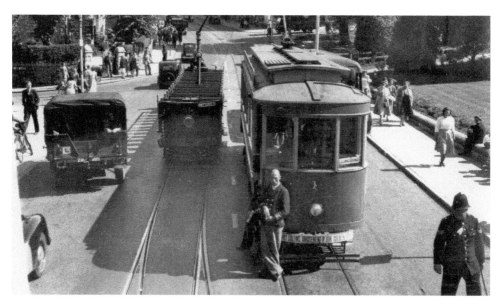

St Paul's Church is to the right and as can be seen the railings have been removed. The Union Church is in the top left hand corner of the picture on the corner of Sea View Road. The open-topped tram was known as a 'toast rack'. Buses still stop at this spot today.

turn into airplanes. Indeed, the Mosquito fighter-bomber, the fastest plane that Bomber Command had, was made out of wood because the makers could not find enough metal. In Germany the authorities collected some 3,000 tons of metal by seizing church bells under an order entitled 'Artistic Protection'. Sensibly, Mr Beaverbrook did not touch the bells, thus after the Battle of El Alamein, on Churchill's suggestion, the bells of St Paul's Church, Colwyn Bay, rang out in celebration. The picture below shows the St Paul's Church garden without the railings. Outside Rhos Park on Penrhyn Avenue you can still see the holes in the foundation stone where the railings once stood. A war time poem went thus:

My saucepans have all been surrendered
The teapot is gone from the hob,
The colander's leaving the cabbage,
For a very much different job.
So now, when I hear on the wireless,
Of Hurricanes showing their mettle,
I see in a vision before me,
A Dornier chased by my kettle.

BACON AND HAM DIVISION AT PENRHOS COLLEGE

In June 1940, the twenty-one-year-old Miss Joan Verner Rees and her colleague, Peggy Caird, were driven from London to Colwyn Bay by the Ministry of Food driver, Harris Carter. They were to be part of the Bacon and Ham Division which was housed in Penrhos College. They had been given a slip of paper on which was written the information about their billet in the town, Woodlands, Woodland Avenue, Old Colwyn. To the utter astonishment of their hosts, Mr and Mrs Llewelyn, Mr Carter drove straight up the steep narrow lane of Withington Avenue from Wellington Rad, instead of going round via Bodelwyddan Avenue, possibly the only time this feat had ever been attempted successfully. The following day Miss Rees (later to marry Mr Vernon Parsons who had served in the army) reported for duty at the College where she was to work, as John Bodinnar's (later to be knighted) secretary. Mr Bodinnar was the managing director of the largest bacon curing business in the country, C. & T. Harris (of Caln) Ltd. The firm supplied the armed forces as well as the British people with large quantities of tinned and fresh food throughout the war; in 1942 they had 111 travellers and van salesmen hurtling all over the country. In due course, he was appointed the Commercial Secretary to the Ministry and moved to the Colwyn Bay Hotel taking Miss Rees with him as his Personal Assistant. The two of them would spend a fortnight in Colwyn Bay and then travel to London where they would spend a fortnight at the Ministry's London headquarters in Portman Square, after which they would return to the Colwyn Bay Hotel and start the process all over again. As Mrs

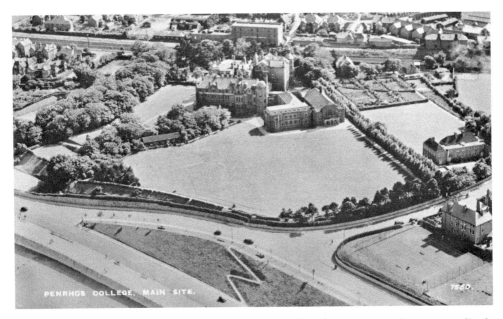

The Penrhos College site seen from the air, c. 1960. Daniel Allen's Depository can be seen immediately behind the school, beside the railway. Llannerch Road East is to the bottom right.

Parsons admitted seventy years later, she was thoroughly spoilt by Mr & Mrs Llewelyn, their son Bill and daughter Con at her digs in Old Colwyn. Penrhos College boasted an excellent canteen and a large chapel which was used by the Ministry as a ballroom where every Saturday night there was a dance and all were welcome. The clocks were put on double summer time so that the revellers leaving at 11.30 p.m. walked home in the evening light.

THE AGRICULTURAL PLANS BRANCH & PROFESSOR JOHN RAEBURN

All governments are keen on statistics, especially those which confirm their own point of view and this was true even in the Ministry of Food during the Second World War. Professor John Raeburn was a respected agricultural economist when he joined the Ministry in 1939 and found himself in Penrhos College engaged as a statistician. Two years later he was in charge of the Agricultural Plans Branch. It was the professor who encouraged the British people to produce their own food which in turn boosted morale by allowing civilians to share actively in the war effort. At one point in the war there was a glut of carrots and the professor let it be known that carotene, which is believed to help night vision, was largely responsible for the RAF's increasing success

The very place where John Raeburn may have bought his fiancé's engagement ring, W. Jones & Son, Greenwich House, 14 Station Road. W. S. Wood's department store was next door to the right; today it is known as Peacock's. Mr Jones' business did not survive long after the war. Ironically, his business did better during the war with the custom he picked up from the Ministry of Food civil servants, than it did after 1945 when they all departed leaving the cash strapped locals to their own devices. People came from far and wide to shop in Station Road as it was considered to be a very fashionable area, with Daniel Allen's department store; Anstiss' and Neville's, the two drapers stores; Frank Little's grocery store; Wallis' shoe shop; Rhydwen Jones & Davies' house furnishing store; A. S. Nevatt, the outfitter's; Harry Pinnington's Cartmell Hotel and Ernest Thorpe's Café Royal; as well as Miss Elizabeth Nicholson's fancy goods shop.

in shooting down enemy bombers. People eagerly tucked in to carrots, believing this would help them to see more clearly in the black-out. The ruse not only reduced the surplus vegetable but also helped to mask the chief reason for the RAF's success – the increasing power of radar and the secret introduction of an airborne version of the system. Happily for the professor, it was in Colwyn Bay that he met Mair, a young nurse, who he married in 1941.

NELLIE'S SPEAKEASY

Nellie Jones was outspoken, outrageous, hard-working and fun. The shop (Carlton's on Abergele Road) which she ran with her husband, Trevor, was small, bespoke and a centre

Carlton's on the right in 1915.

The original site of Carlton's can be seen to the left of the lamppost today.

of local gossip, and it sold everything under the sun. At the rear of the shop was a tiny café where, during the war, she served ham, eggs, chips and beans on toast for soldiers and the farmers when they came down from the surrounding hills. Rationing did not seem to be a concept which held much sway in Nellie's domain, but no doubt the farmers were good, reliable, clandestine suppliers of wholesome food. It was said in the war that there were three ways of spreading news – the telephone, the telegraph and the 'tellnellie'. You never saw a Ministry of Food civil servant or clerk in the backroom, as it was reserved exclusively for the home-grown locals. Years later at a town social get-together Nellie was asked by a nosey-parker if she had any children. In a loud jovial voice she replied: 'Oh no, you see Trevor was in the desert during the war and he got sand in it.'

OIL AND FATS STATISTICS DEPARTMENT

This department was housed in the Sunnybank Hotel, just across the road from the Colwyn Bay Hotel, on the Upper Promenade. The owner of the hotel, Mrs Hanson, was given twenty-four hours to vacate the property and find somewhere else to live.

A picture taken in 1978 from the top of the St Paul's Church tower, showing the remnants of the wartime world. Pat Collins' multi-coloured funfair is amongst the trees, the Neptune Fish Bar is on the corner of Sea View Road and Bay View Road, and the Co-op is on Sea View Road (now both demolished) behind the Union Church, bottom right, now derelict and for sale. The Royal Pub on the left, on the corner of Sea View Road, was named in honour of Queen Victoria.

Cec Owens, one of the young men working for the department before being called up and going to war, enjoyed himself here. The most enthralling bit of the work was waiting for Saturday night when he would go to the dance at Penrhos College with all the other clerks. This was where he first put his arms around Brenda whom he later married. Seventy years later he can still recall a civil servant from London announcing to him that he had been to 'Aburbugalery'. It took him half an hour to work out that he had been to Abergele! In 1939, most of the locals had never seen a Jewish person before, but with the arrival of the Ministry of Food came quite a number of Jewish personnel. Many lodged in Colwyn Bay and some went to Llandudno to work for the Inland Revenue which had relocated there from London. With the help of the Brethren of St Tudno's Masonic Lodge in Llandudno, the Jewish community was able to use the Masonic Lodge premises for their own Masonic meetings. Their version was called the Chequered Cloth Lodge, because in days gone by the Jewish people used to use a chequered cloth to collect taxes. They also received permission to use the building as their synagogue.

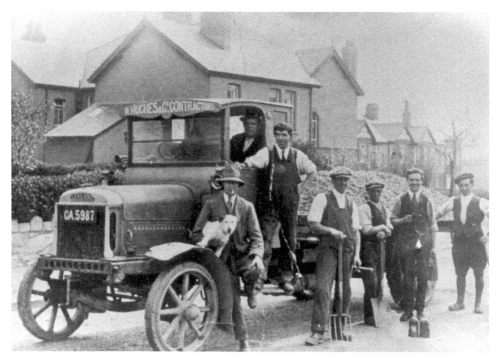

William Roger Hughes.

ROGER HUGHES & CO.

Towards the end of the nineteenth century, William Roger Hughes began the quarry business on Llysfaen Road which he named Plasgwilym Quarry. In due course his two sons, Frank Roger Hughes and Hugh Price Hughes, took over the running of the business and it was they who worked manfully during the war to provide material for building such things as the gun emplacements on the Great Orme (some of which still exist) and the aerodrome at Breese Heath in the Midlands which was used by fighter aircraft. The work carried out at Plasgwilym Quarry, here in Colwyn Bay, was vital to the war effort. In due course Frank's son Gerald took over the running of the quarry and it is now owned by Daniel UK.

While Roger Hughes & Company was making every effort to thwart the threat of a German invasion, some of the London civil servants of the Ministry of Food were helping to prop up the bar in the Colwyn Bay Cricket Club. In 1941, Harry Pinnington, the Chairman of the Club, 'heartily welcomed the members of the Ministry of Food'. The following year, due to the shortages, it was decreed that 'no member was allowed to order beer in pints and there were no doubles of short drinks and then only two drinks per person was allowed'. Yet at Christmas time 1945 the committee organised a party in honour of the Ministry members and admitted that although their initial arrival had placed heavy demands on the Club's resources, the newcomers had proved to be a tremendous help in putting the Club on its feet. 'Charities as well as the Club had benefited'.

CANNED CONDENSED MILK DIVISION

The Division began its life in the Rothesay Hotel on the promenade and after a couple of years moved up to the Pwllycrochan Hotel. Grace Boyce was one of the young civil servants sent from London, where she had been working on the Ground Nut Scheme in a building used before the war by Westminster Teacher Training College. She found the bracing North Wales air invigorating and the Canned Condensed Milk Division confusing. Her main task was to look after and maintain the various depots around the country where the canned condensed milk was stored. Mr Lyons of the London Corner Houses was in charge with Mr Drisedale and Mr Green, attempting to keep all the London girls in order. For some reason the Prime Minister of Holland called in to see them working; presumably, as his country had been overrun by the Germans, he had little else to do.

The Rothesay Hotel.

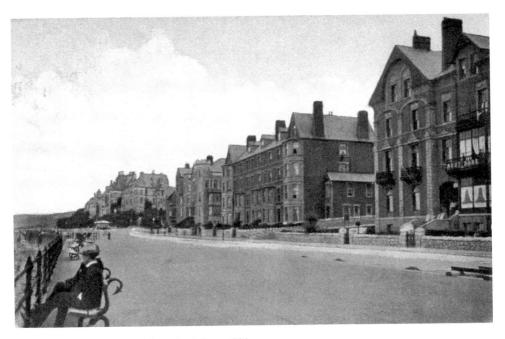

The Rothesay Hotel is second from the right, *c.* 1920.

FIFTH COLUMNISTS

1939 and 1940 were jittery years when everyone was nervous and wary of what would happen. The Royal Welch Fusiliers arrived and requisitioned anything green – parks, bowling greens, playing fields, the gardens at Eirias Park – as potential sites for their camps. It was rumoured that when the Germans had invaded and overrun the Netherlands many of them had been disguised as nuns. Having heard this disquieting news, four members of the local Home Guard surreptitiously followed some nuns back to their convent in Walshaw Avenue. The crestfallen men were invited inside for a warm cup of tea.

THE ST TUDNO'S LEISURE CENTRE

This hotel (now Linden Court, No. 16) on the corner of Upper Promenade and Sea Bank Road was used as a recreation centre by the young civil servants where they would go to play table tennis and darts. There was no bar but it was equidistant between Penrhos School and the Colwyn Bay Hotel where there were dozens of people hard at work all day and looking for a little innocent relaxation in the evening. The eighteen-year-old Audrey Andrew from the Milk Division used to play darts here while her pal Grace Boyce from the Egg Division, seeking out a little more excitement, used to go dancing at the Comrades' Club in Colwyn Bay. Nevertheless they deserved their leisure time, for during the war, through their efforts, the poorer people of Great Britain grew healthier and stronger due to a policy of education and fairness. There was also free school meals and free milk and orange juice for children. This had never happened before.

THE BRAID'S GARAGE WAR MACHINE

The entire staff of Braid's Garage, the management, the mechanics and the domestic staff, made an invaluable contribution to the allied victory in the war. Sir Stafford Cripps, the Minister of Aircraft Production, visited the garage in June 1943 and afterwards sent a letter to 'the workers' which ended, 'Stick to it and together we will win the victory'. The whole capacity of the garage was given over to the production of 25-pounder shells, aircraft components, tank parts and gun carriage axels, as well as assembling Dodge reconnaissance vehicles, Chevrolet tilt covered trucks, Humber armoured cars and American jeeps. They manufactured over one million of the shells and estimated that they completed a shell every 22 seconds per working shift. By the end of 1943, because most of the men had left to fight abroad, only 5 per cent of the staff was skilled while the rest had no formal engineering knowledge and of this

The Convent Walshaw Avenue to which the Home Guard followed the nuns.

The secret location for the Ministry of Food unknown to the Germans whether dressed as nuns or not.

The St Tudno's Leisure Centre.

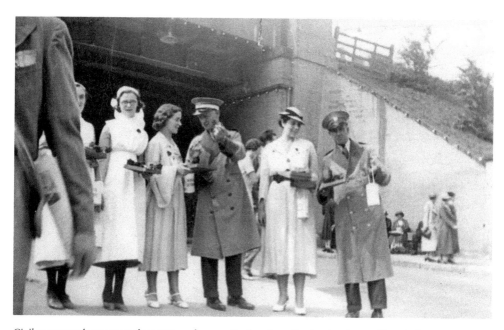

Civil servant volunteers on the promenade opposite the pier collecting for the local hospital.

The workers at Braid's Garage are unloading American jeep parts which they assembled in the garage. Bryn Euryn can be seen in the background.

As so many jeeps were being assembled at such a spectacular rate they had to be parked on the surrounding roads. This is Gregory Avenue. There are now houses on either side of the road and the road surface have been tarmacked.

Conway Road, where Braid's was built (on the right) about thirty years before the war began. The teenage Joan Bellis and her young brother, Derek, were walking home along Conway Road and while passing the garage one of the mechanics shouted at them, 'you two want to wait until the end of the war and then you can buy one of these jeeps for £5'. Derek went home and began to save his pocket money.

number most of them were ladies. It is because of the dedication of people like the staff in Braids, as well as those fighting in the forces, that we won the Second World War.

The shell plant operated for over three years without a break, twenty-two hours per day with two working shifts, while convoys of not less than fifty vehicles per day were delivered to various fighting units. Seventy years later the building is still a garage, now owned by Slaters of Abergele.

THE VACEES IN THE CROFT

In 1939, Mr James Robinson was the managing director of the Manchester textile firm, Messrs Mather and Plat, and he lived with his wife Ruth and five grown up children at the Croft, a large house which still exists on the corner of Brackley Avenue and Oak Drive. At the beginning of the war hundreds of children were evacuated to Colwyn Bay from Liverpool. One large group arrived and were left at Rhos-on-Sea Golf Course where it was arranged they would be chosen and collected by local residents. Jim Robinson (no relation to the owners of the Croft) his brother Bob and sister Mary and their next door neighbours, Theresa and Jim Quinn, from a slum area of Liverpool, must have looked particularly unkempt and were left until the end, no one having

Mr and Mrs Robinson are pictured in the top right hand corner of the picture and Jim is the boy standing second from the left in the second row. Mr & Mrs Robinson's only son, Clifton, joined the RAF and was killed early in the war, flying over the English Channel, having been involved in a fight with German 'planes. A stained glass window is dedicated to his memory in St Andrew's Church, on the corner of Lansdowne Road and Kings Road.

chosen them. Mr & Mrs Robinson's daughter Helen (known as Tommy because she was a 'tom-boy') looked at them and said, 'Hello, you lot had better come home with me.' When the five of them arrived at the Croft, Tommy's mother was waiting on the door step; she looked at Jim and said, 'What is your name?' He was twelve years old at the time and replied, 'Jim.'

'No,' she said, 'what is your real name?'

He said, 'Robinson.'

'Well,' she responded, 'that's my name too.' She put her arm around his shoulder and said 'Let's all go inside'. And Jim recalls, seventy years later, that that is what they did and stayed there, in paradise, for the whole of the war. There were in fact eleven evacuees in the house: the three Robinsons, the two Quinns, Olive Green, who was the niece of the Croft's cook, and five children of the Sandford family.

MR BUCKLEY'S PARROTT

Mr Joe Buckley, an elderly man in 1941, lived in a small lodge building in the grounds of the large house known as Rhiw Grange at the top left hand corner of Rhiw Road.

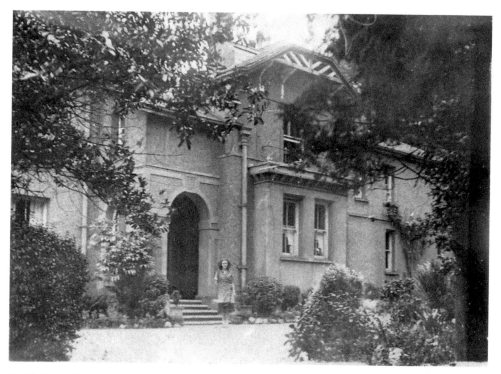

Phyllis Reynolds on the door step of Rhiw Grange.

The present cul-de-sac, Rhiw Grange, takes its name from the original house which was demolished to make way for the present bungalows. One day Mr Buckley asked a kindly neighbour, Rene Deakin, if she had any connections in the Ministry of Food because he said, 'Polly is in dire need of some good sugar.' Mrs Deakin wanted to help and assumed that Polly was Mrs Buckley. She knew Mr Aneurin Jackson who worked in the Metropole Hotel in the Sugar Division and asked him to help. Somehow or other, without coupons, he was able to surreptitiously scrounge a 1 lb of sugar which he secretly handed to Rene, who in turn gave it to Mr Buckley, who explained that Polly was in fact his pet parrot and that the sugar would save Polly's life. After the war Aneurin Jackson set up in business in the Market Hall across the road from his war time place of work, where he sold delicious bacon bones, split peas and other delicacies.

TOC H CANTEEN, THE COMRADES' CLUB

During the war the club was a haven for countless service men and women and for Ministry personnel. The building was on Douglas Road, on the present car park opposite the Youth Club. In the picture above Albert Place can be seen in the

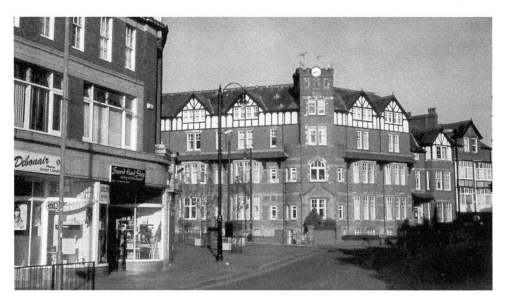

The Metropole Hotel in 2011.

background. The canteen was started by the Women's Temperance Association when they started collecting money to provide and equip the building for the benefit of the troops. It was open for six years and it is estimated that 2 million cups of tea and coffee were served and 100 tons of bread were consumed. The club became well known over a large area of North Wales and it is thought that roughly 600 to 700 service men and women were catered for on a daily basis. Colwyn Bay also benefited financially as £20,000 was spent in the town on purchases for the canteen. The Club secretary was Mr C. D. Yonge who was a school master in Rydal School. One of the young ladies who served the soup was Aline Firth. When she was born her God Mother was acting in a production of 'The Sorcerer' on the pier and Dr Macdonald Brown, who delivered the baby, decreed that the new Firth infant should be baptised with a theatrically operatic name. The baby's father, Len Firth, decided to have her christened with the name of her God Mother's character in the play *Aline*. Shortly after the war ended Aline was voted as the 'Savings Queen' and no one has held the office since. During the war, catering for families was a complicated task. In an article in Vogue in September 1942 entitled 'Fuel Saving in the Kitchen', housewives were instructed to use fuel sparingly in cooking; it must not be wasted over washing-up, neither should soap be used. It was suggested that there should only be 'two wash-ups a day, after main meals are enough. No need either, to wash saucepans after each use: the one in which luncheon meat or vegetables were cooked will come in again at dinner-time, for veg or meat, with added flavour.'

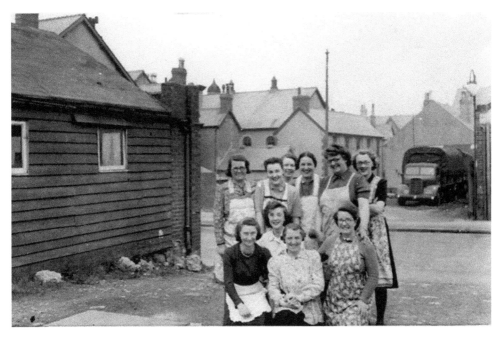

Toc H canteen workers. Back Row l–r: Annie Firth; unknown; Maud Hughes; Poppy Owen; Elsie Cubbon; Freda Weeks. Centre Front Row: Mrs Jagger. (The Club building can be seen on the left.)

THE BRITISH RESTAURANT

These restaurants, originally called 'Community Feeding Centres' until renamed at Churchill's suggestion, were run by local authorities with Government encouragement and offered cheap, off-ration, plain fare at cost price. As the Ministry of Food was based in Colwyn Bay there was no way the local authority could avoid its responsibility in this regard. The town's restaurant was opened on 10 January 1942 in the Congregational Church Lecture Hall in Sea View Road, below the main church building. At the beginning of the week, when the Ministry civil servants were flush with their wages, they would go to the posh restaurants in Penrhos or Pwllycrochan or The Metropole, but by Friday when they had little money left, they would go to the British Restaurant for a shilling lunch. Mrs Izod, wife of a Ministry of Food official, pronounced herself amazed at the machine used for slicing bread. The idea of the restaurants was to avoid a repetition of the inadequate diets of the 1st World War. The restaurant seated 150 and a shilling would buy you soup, roast lamb and vegetables, pudding and tea or coffee. To make sure you did not run away with the crockery and cutlery, it was all stamped 'Colwyn Bay British Restaurant'. Mind you not everyone thought that eating sensibly was a good idea. In 1941, Lord Woolton briefed the War Cabinet on the necessity to ration canned goods. Churchill murmured in sorrowful jest, 'I shall never see another sardine.'

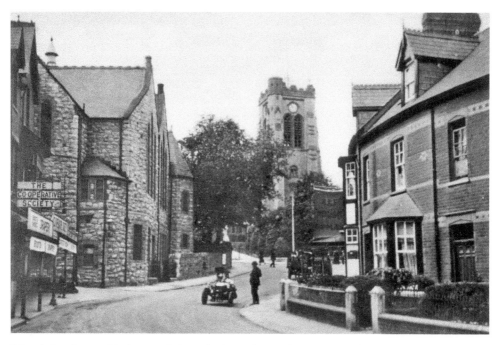

Taken before the war, this photograph shows the Co-op shop on the immediate left and then the Congregational Church with the room which housed the British Restaurant below the church. St Paul's Church is in the background and all the houses on the right are now shops on the ground floor with flats above.

THE GOVERNMENT BUILDINGS

There were ineffectual protests in 1942 at the building of the single-storey government offices in the fields below Bryn Euryn, between Tan-y-Bryn Road and Dinerth Road. This was wartime so the worries of the local people were brushed aside and the building went ahead. In fact they were conceived as emergency hospital wards for the casualties that were expected had the Germans successfully invaded the country. All the floors were designed with an inbuilt slope to make sluicing them easier. Local Dinerth Road residents recall that at the end of the war the two blocks nearest the road were stacked full, floor to ceiling, with gas masks. The Animal Feeding Stuff Division of the Ministry of Food transferred here from the Mount Stewart Hotel and Miss Lumley Davies was joined by a Carnival Queen from Southend-on-Sea. One of the jobs given to the ladies was to monitor the animal foodstuffs that were being brought by sea from America and sometimes there were long sad faces as reports came through of the sinking of these ships in the Atlantic. In the ground beside the buildings, running from Tan-y-Bryn Road to Dinerth Road, alongside what is now Stewart Drive, experiments were carried out to discover what made the best compost or manure, so that recommendations could be made to all those who had taken up the advice of the Ministry to dig their own allotments. In the 1970s, when Cec Owens went to live in

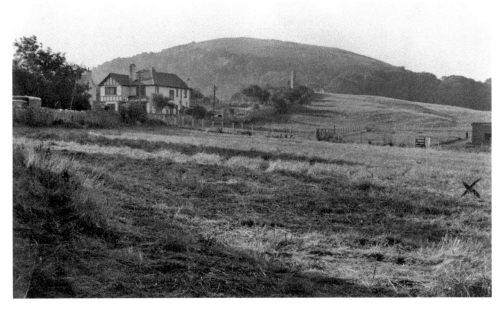

Tan-y-Bryn Road on the left and the fields on which the government buildings were erected.

The government buildings in 2011, built on the fields shown in the picture on the previous page, pictured from the Dinerth Road entrance looking exactly as they did seventy years earlier.

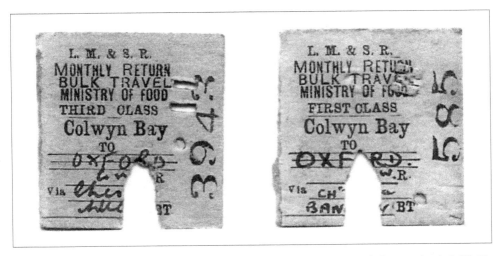

Ministry of Food 'Bulk Travel' card rail tickets (which were known as 'blank cards' because the clerk filled in the space for destination) used for less frequently used destinations by officers working in such places as the government buildings. The serial numbers on the right give an indication of the number of passengers travelled with such tickets up to the respective date of issue; 11 November 1943 on the left (Third Class) and 31 August 1942 on the right (First Class). These particular tickets would have been issued in exchange for warrants and a discount would have been applied. For more frequently used destinations such as London there would have been a printed stock of tickets issued. Petrol was scarce; Ivor Novello was imprisoned for using 'black-market' petrol. Everyone travelled by train, even the boss, Lord Woolton, came to Colwyn Bay by rail.

a house on the Drive and had his own allotment opposite his home, he discovered that whatever he planted shot up in no time, producing luxuriant vegetables because of those war time experiments. One day, while on secondment in the Colwyn Bay Hotel, Miss Davies recalls all the telephones kept ringing and messages were given to vacate the building immediately because there was a mine in the sea. No one took the warning seriously until they were eventually made to leave the building, whereupon they all went down on to the promenade to have a look at the bobbing bomb! The only thing that concerned the Ministry of Food workers was whether the mine would hit the Colwyn Bay Pier, because they were all due at a dance there that evening. Sixty-eight years later the government buildings are still there and are still used by various local authority agencies.

MI5

During the war, the North Wales regional headquarters of the MI5 Secret Service was housed in the Melfort Hotel, on the corner of Kenelm Road and Llannerch Road East in Rhos-on-Sea. When it was requisitioned in 1940 the owners, Mr and Mrs J. M. Clay-Beckitt, had to leave the property within twenty-four hours. Mr and Mrs Clay-Beckitt had inherited the hotel from Mrs Clay-Beckitt's father, who collected hotels as a hobby.

The MI5 headquarters in Colwyn Bay

At one stage he owned the Melfort, the Silver Howe (also on Llannerch Road) and High Lawns on Rhos Road. In 1939, they had a full staff to run the hotel while they kept a watchful and disinterested eye on the operation. After the war, demonstrating the change in the country's fortunes, Mr Beckitt was the hotel receptionist and Mrs Beckitt was the waitress. Capt. Finney, the Regional Security Liaison Officer for MI5, was described by one of his superiors as being "gratifyingly un-inquisitive about actual details of the various cases". He was in charge and he lodged at no. 10 Victoria Park. His telephone number (Colwyn Bay 2862) was given out to agents and spies who did not necessarily want to report to the Melfort Headquarters. Capt. Finney was reported as saying, "If I cannot get accommodation for the agents by fair means I shall use foul methods." Under the secret plan named 'Hegira' arrangements were made that, in the event of German invasion, MI5 agents would be transported to the Melfort Hotel. The three most important agents were separated from the others; Wolf Schmidt would be looked after at the Swallow Falls Hotel, Betws-y-Coed, Arthur Owen at the Eagles Hotel, Llanrwst, and Gwilym Williams at the Ferry Hotel, Tal-y-Cafn.

THE QUEEN'S HOTEL MAP ROOM

The hotel had been built in 1899 to commemorate Queen Victoria's Diamond Jubilee, but from 1939 to 1945 it housed the Ministry of Food map room, where a host of young ladies traced the movement of food from around the world and its distribution around Great Britain. The map was a huge multi-coloured affair, laid out on a table in

the middle of what had been the hotel lounge. Food was transported from Australia (meat and butter), South Africa (sugar and oranges), South America (grain and meat) etc. The map indicated the distances the food had to travel before it reached the British housewife's table. Sugar (from 4,000 to 11,200 miles), dried fruit and rice (11,200 miles), tea (11,500 miles), lemons (1,500 to 6,000 miles) and so on. Ships full of grain would arrive at Liverpool docks and the Ministry of Food clerks would arrange for the sacks to be cleared of the weevils with which they were infected. There was a good canteen in the hotel which boasted of its 'superior cuisine'. The picture below shows the road through Old Colwyn to the Queens Hotel in around 1910.

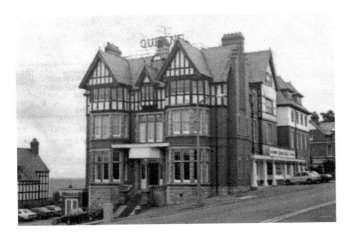

The Queen's Hotel.

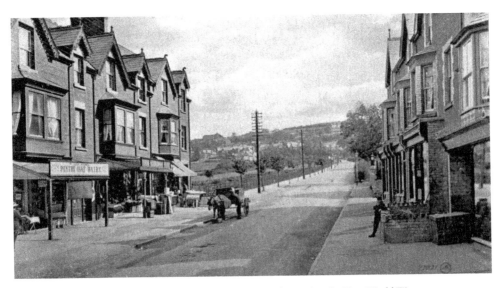

The road running through Old Colwyn to the Queen's Hotel just after the First World War.

THE WIRELESS COLLEGE

The college building was at the far end of East Parade; the college and the Parade have now been demolished to make way for the A55 and a plaque in a car park now commemorates the the work done by the College in training radio operators, many of whom lost their lives in the Merchant Navy during the war.

One such pupil was Idris Thomas from Penmaenmawr who was killed in 1942, at the age of eighteen, when his ship *Stornest* was sunk in the Atlantic by the U-boat U706. Gordon Scott Whale originally opened the North Wales Wireless College in Caernarvon in 1918. He then moved it to Colwyn Bay in 1923. Mr Whale retired in 1935 but returned five years later to help with this vitally important war work. In 1942, Mr Whale staged a variety entertainment in the college theatre to raise funds for 'the purchase of war weapons'. Hugh Lloyd, who was later to appear in *Hancock's Half Hour* and *Hugh and I*, was the compère. For a while during the war the college moved, along with the girls from Penrhos College, to Chatsworth House in Derbyshire.

The civil servants were amazed to find themselves in a land where the teaching of naval wireless telegraphy in the Wireless College was juxtaposed with a rural farming community. John Roberts, of Dol-lwyd Fawr (Big) Farm, Dolwyd, just down the road from Mochdre, still travelled by train to Abergele for the weekly horse market. If he bought a horse (and it would not have been broken in) he would put it on the train and travel with it back to Llandudno Junction. After leaving Mochdre Station, as the train passed Dolwyd, he would lean out of the train window and wave vigorously to

The College building, with the students from Arfon House School, was at the end of East Parade.

Where the Wireless College once stood.

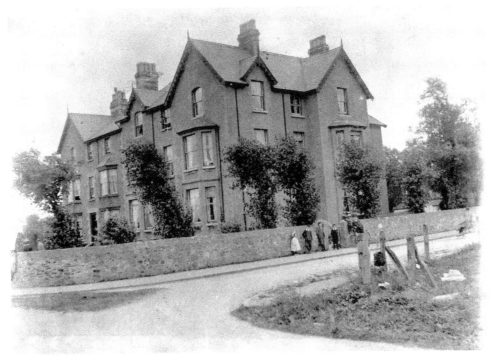

Three houses, left to right: Passenfell, Pendorlan and Olive House. Gordon Whale transformed Olive House into the Wireless College.

alert his farm workers that he needed their help with the farm cart to take the horse back to the farm from the Junction Station. In the 1940s Dolwyd was still written as Dol-lwyd which translated for the English Ministry of Food employees was 'Grey Meadow'. These were also the years when a farmer from a farm above Dolwyd would walk his sow along Conway Road, by a piece of string attached to its hind leg, to Glan-y-Wern Farm to mate with Thomas Lloyd's boar. Mr Lloyd ran the farm but it was owned by Mr Levy (a Jewish man who was content to rear pigs). he bought 109 Marine Drive, Rhos-on-Sea, and installed his wife, two children and a maid in the house for the duration of the war. Quite what the urban-reared members of the Ministry of Food made of all this is unclear. What is known, however, is that they got used to it, embraced it and many were reluctant to go back to Guildford after Hitler's hold on Germany had ended and the supply of food was restored. It is possible that the Ministry workers were unhappy at returning south because they knew how much they would miss the extra fresh food which John Roberts and Thomas Lloyd were able to supply to their families on the quiet.

THE UNRELIABLE TRAMS

The London civil servants were not used to the laid back world into which they had been thrown by the evil consequences of Hitler's actions. During the war everyone in Colwyn Bay made their way to work either by foot or by using the trams. The trams ran on electricity which was fed to the overhead wires from the electricity sub-station on Ivy Street. Unfortunately the man whose job it was to open the building early each morning and turn on the machinery that started the flow of electricity specifically for the trams invariably overslept and so the manager, Mr Hughes, often had to be roused from his bed to perform this task while queues of uncomprehending civil servants and typists built up at the various tram stops and the important work of feeding the nation was put on hold. Once the bleary-eyed Mr Hughes had thrown the switch, the civil servants hurried on their way to work at such places as the Colwyn Bay Hotel, where sophisticated southerners penned morale boosting posters such as that with the slogan:

> Better Pot-Luck
> (with Churchill today)
> Than Humble Pie
> (with Hitler tomorrow)
> Don't Waste Food!

The photograph overleaf shows a tram travelling along Tramway Avenue (now Penrhyn Avenue) in the 1930s. Today, Fortes café is on the right-hand corner and the tram is passing outside the present site of Beardsall's the jeweller's. The small

stone buildings immediately behind the tram are still in place today and can be seen on the lane to the Rhos Manor car park. The house behind the two poles on the right has been demolished and replaced by the Haddon Place flats. The first section of the tramway, from West Shore, Llandudno to the tramsheds on Penrhyn Avenue, was opened in October 1907. It was extended to Colwyn Bay the following year and to Old Colwyn in 1915. After the war, when the trams were extensively used, they were declared to be in a very healthy financial position. After 1950, with the ever increasing use of private cars the situation got steadily worse. The tramcars eventually ended their run on 25 March 1956.

ADMINISTRATION & PAY DIVISION IN THE METROPOLE HOTEL

Miss E. Griffiths was the manageress of the hotel. When the Ministry of Food took it over in 1940 she promptly lost her job. This was an important hub of the administration of the work of the Ministry. Like at the Pwllycrochan Hotel and Penrhos College sites, there was an in-house canteen for the civil servants and clerks. T. Alun Hughes & Co., a local building-firm that had built most of the houses on Yerburgh Avenue before the war, carried out a lot of joinery work for the Ministry. Their builders' yard, shown in the photograph, was situated at the back of Llannerch Road West. The company employed two joiners who did not get on and would not talk to one another other. Another employee, Herbert E. Hughes, remembers that an order came in for a hundred drawers for desks in the Metropole, but because of the joiners' stupidity in not speaking to one another, they both made a hundred drawers each and Mr T. Alun Hughes was left with a hundred useless drawers. After the war the premises were never used as a hotel again. The ground floor was used as a restaurant and bar run by Charles Porter and Philip Arundale and on the first floor there were offices. It has now been converted into very useful flats for the elderly, administered by a Housing Association.

The old T. Alun Hughes' builders yard at the back of Llannerch Road West. Bryn Euryn is in the top right-hand corner of the picture. The A55 now runs beside the railway line.

While Mr T. Alun Hughes was producing too many drawers, the Ministry officials were using too many telephones. Mr Groves was ordered to check on the number of 'phones in use in the Colwyn Bay Hotel. He visited the office of one senior Director only to find four on his desk; one was to his secretary in the next room, one was to his Deputy on the next floor, one was to the office switchboard and the last one was a direct line to the GPO exchange. To the chagrin of the Director, Mr Groves said, "Right, choose the one you want to keep and the rest will be removed." The fellow nearly had apoplexy.

CARTMELL'S HOTEL

This first picture below shows the hotel in 1901. At the time of the Second World War it was no longer really a hotel; it was by then a very good restaurant run by Harry Pinnington, with a couple of bedrooms upstairs somewhere. It was on Station Road, next door to Daniel Allen's department store, advertised as 'The Largest and Most Modern Furnishing House in the North West'. In later years it changed hands and became Lowe's Restaurant, but during the war it was a regular watering hole for the more affluent and

CARTMELL'S (LATE MOON'S),

COMMERCIAL AND TEMPERANCE

HOTEL and RESTAURANT,

STATION ROAD, COLWYN BAY,

Opposite General Post Office and one minute from Station.

Refreshment Contractor and Public Caterer.

The Large Dining Room has accommodation for 200 persons.

LUNCHEONS, DINNERS AND BANQUETS.

Special Terms for Choirs, Schools, and Picnic Parties.

Wedding Breakfasts and Ball Suppers supplied.

High-class Confectionery.

Bride, Christening, Easter and Christmas Cakes of the Best Quality.

Nat. Telephone: 0196, Colwyn Bay.

Proprietor: J. D. CARTMELL.

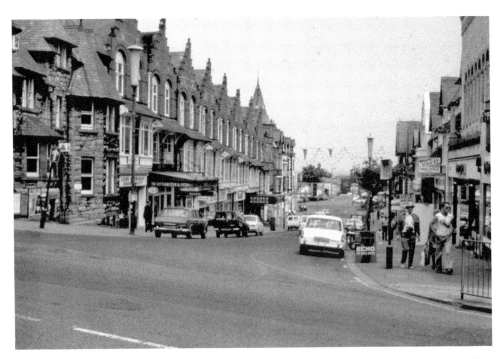

Station Road after the war, when Cartmell's premises became Lowe's Restaurant. It was sold in 1978 when the picture was taken.

senior civil servants. The various Masonic Lodges met there for their 'festive boards', where the local members, supplemented by many civil servants associated with London Lodges, would never know what they were going to eat until it was placed before them. There were no menus during the war. It was always assumed that Mr Pinnington, a future Chairman of Colwyn Bay Magistrate's Bench, had a very good relationship with the many local farmers and the Ministry civil servants never enquired about the matter. The second picture shows Station Road after war when Cartmell's premises became Lowe's Restaurant which was sold in 1978 when the picture was taken.

THE MARINE HOTEL TRANSIT CAMP

The Marine Hotel (known as Morannedd), next door to the Lockyer's Hotel on Marine Road, was used to billet newly arrived Ministry of Food personnel before they found more permanent accommodation. In 1942 Audrey Andrew arrived from Liverpool and was sent straight to the hotel. She was appalled at the dirty net curtains and decided to wash them, whereupon they promptly disintegrated. The ladies were told that if they mentioned it to the requisitioning officers they could be found accommodation with their friends. Audrey had met Margaret in the Marine and they became good friends, so they decided to ask if they could live in the same house. As inevitably happens when government officialdom is involved, Margaret was sent to Old Colwyn to live with two old ladies and Audrey was sent to a house in Rhos-on-Sea! Audrey Andrew and her friend Margaret, and thousands of other ladies, had their expectations of themselves and society's view of them transformed forever. The war changed everything; half of all the women in domestic service left it, never to return, upper-class women learned to boil their own eggs and the divorce rate soared. Across class and income divisions, women who until 1939 had never questioned the conventions that ruled their lives found themselves required to take on new and often terrifying jobs. Because of the restrictions imposed by the officials in Colwyn Bay many of the local ladies even found that they were able to bake an eggless, milkless, butterless cake.

THE DRIED MILK DIVISION AND OIL & FATS DEPARTMENT IN PWLLYCROCHAN HOTEL

Mr Irving lived on a yacht in Conwy harbour and was in charge of the Milk Division. The hotel, at the top of Pwllycrochan Avenue, had been a very superior hotel. In the early 19th Century it had been the home of Sir David and Lady Erskine. Mr Lloyd was also based in the hotel, along with his secretary Margaret Pollitt (wife of Fred, the future teacher at Colwyn Bay Grammar School). Mr Lloyd had been seconded

The summer scene that would have greeted Audrey on Penrhyn Avenue (originally known as Tramway Avenue) during the war, as a 'toast-rack' trundles along. Audrey Andrew and her friend Margaret and thousands of other ladies had their expectations of themselves and society's view of them transformed forever. The war changed everything; half of all the women in domestic service left it, never to return, upper-class women learned to boil their own eggs and the divorce rate soared. Across class and income divisions, women who until 1939 had never questioned the conventions that ruled their lives found themselves required to take on new and often terrifying jobs. Because of the restrictions imposed by the officials in Colwyn Bay, many of the local ladies even found that they were able to bake an eggless, milkless, butterless cake.

from Unilever and was in charge of the Oil and Fats Department. He had been billeted with several other men on a disgruntled landlady who was upset at having to cancel her summer visitors and provide bed and breakfast and evening meal at a guinea a week for civil servants. Mr Lloyd said she made a most wonderful rice pudding; the trouble was that they had it every evening. As a former hotel there was an excellent kitchen and dining room at Pwllycrochan. It was so good in fact that Lord Woolton, the Minister, always used to dine there on his visits to Colwyn Bay. Many years later Mrs E. R. Hughes of Old Colwyn, one of the clerks at Pwllycrochan, recalled the succulent aromas wafting down the corridors while she was on fire watching duty. The reward for this service was that the next day they would eat the remnants of the feast in the guise of turkey rissoles. On 1 March 1941 the Royal Welch Fusiliers gained permission from the Ministry to hold their St David's Day celebration dinner in the hotel, at which the Regimental and Home Guard Goat was marched around the tables. The civil servants did not go at their work hammer and tongs all the time. In 1942 Audrey Andrew wrote in her diary, 'not very busy, wrote to Mum'. The Pwllycrochan became Rydal Junior School in 1953.

The Regimental Goat pictured outside the Royal Welch Fusiliers headquarters on Princes Drive.

The right-hand end was the original home of Sir David Erskine and the left hand side was added by Mr Porter when he adapted the building as a hotel. The Ministry of Food took it over in 1939. It had a brief life as a hotel after the war and then it became Rydal Junior School in 1953.

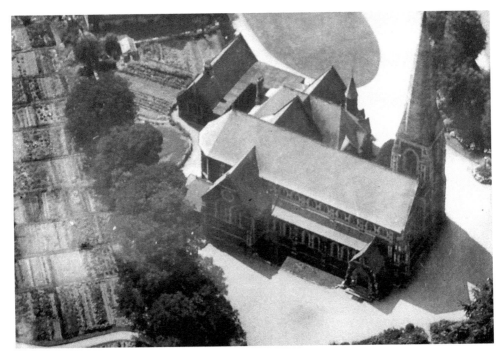

A war time aerial photograph showing St John's Methodist Church.

ST. JOHN'S METHODIST CHURCH

The war time aerial photograph above shows St. John's Methodist Church, (now owned by Rydal Penrhos School) at the other end of Pwllycrochan Avenue from Sir David Erskine's old home, revealing the allotments on the present gardens next door to the church, originally known as Rydal Gardens.

THE CAFÉ PARISIEN

This establishment was actually Taylor's Café and the Empress Ball Room. Unusually for a café, it also housed a roller skating rink where the girls from the Ministry of Food would often congregate of an evening and whirl around. When on leave, Milburn Shanks and his soldier friends would rush there to feast their eyes on these sophisticated London ladies. It is now Steptoe's furniture shop and Tyler T's café and sandwich bar at 59 Abergele Road.

The site of the Café Parisien today.

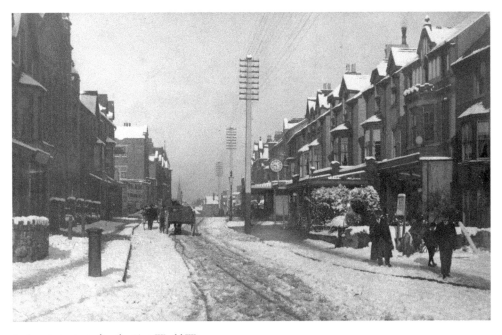

In the winter, just after the First World War.

The headquarters of the Wheat Commission shown in January 2011.

THE WHEAT COMMISSION

Laurette Prendeville, a young lady brought up in Colwyn Bay, applied for a job with the Ministry of Food and was told at her interview, 'Oh yes, we've got a job for you in flour'. She was sent to help in the Wheat Commission in the Mount Stewart Hotel (below) where she and two other young ladies worked on Army Contracts, making sure that the troops were provided with sufficient wheat, grain, oats etc. Mr Albert Ward was in charge of the ladies, who maintained that 'he did the deciding and we did the work'. A senior civil servant, he had come from London where he was used to working from 10.00 a.m. to 4.00 p.m. each day, a schedule he maintained in Rhos-on-Sea, much to the dismay of the rest of the department. Mr Montgomery, his boss, whom the ladies considered to be a very old man, but who was probably about fifty years old, told Laurette and her two colleagues that their work was invaluable and that they would not be moved from the Wheat Commission. Within days of this endorsement, their 'call up' papers arrived. Laurette, who had studied at Bangor University, could spell 'Mediterranean', so she was drafted into the Signals Division of Western Command in Chester. One of her Ministry friends was desperate to join the WRENs because they were provided with very fetching, stylish hats. Although the ladies, on reflection, described their time with the Ministry of Food as a bit of a 'hotch-potch', Mr Montgomery was correct in describing their contribution to the war effort as invaluable. As part of their duties the three ladies had to fire watch at night while

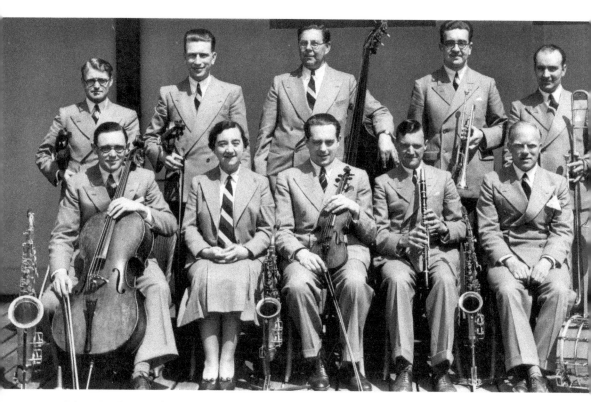

Colwyn Bay Municipal Orchestra with Mr Reginald Stead (seatead centre with violin).

sat on the veranda patio of the hotel, overlooking the sea. They would watch the fires glowing in the distance while Liverpool sadly burned. Many years later, Laurette, now Mrs Danson, was awarded the MBE for her work with SSAFA and became the Mayor of the Bay of Colwyn Town Council.

ANALYSIS DEPARTMENT IN RYDAL SCHOOL

Before he joined the forces in 1940, Edgar Whitley worked for the Ministry of Food as an analyst in the chemistry laboratory of the school; he spent his time analysing dried milk. For the sake of the nations' children it was important that the milk powder was of good quality. Milk was an important part of the 'Blitz Meals' that became standard fare in the air-raided towns, and was only free to those in need. The caterers were reimbursed by the Ministry of Food in Colwyn Bay. People were not as fussy as we are today. For the egg-and-spoon races at the local schools, the teachers used hard boiled eggs so that afterwards they could be used in the children's sandwiches. Other far reaching decisions were made in Rydal. It was decided to limit the amount of sugar an

individual was allowed to buy, and improve the availability of milk and eggs, an edict which ended up helping to make the industrial working classes better fed than at any point in history.

Butchers around the country were experimenting with food because of the strictures being imposed by the Ministry in Colwyn Bay. Sausages were being made out of nothing more than rabbits and broad beans, but were supposed to have a 65 per cent content of meat. Sausages were not rationed, nor were offal and poultry. Argentina was the biggest supplier of meat, which was especially prized because it came unfrozen and was kept in a chilled condition with the result that after the three-week voyage it was nicely hung and ate very well.

COLWYN BAY MUNICIPAL ORCHESTRA

Mr Reginald Stead and the orchestra played twice on Sundays in the Pier Pavilion throughout the war, thus contributing to the atmosphere of relaxation that was a vital part of the war effort. Their music was much appreciated even by the London civil servants who were more used to listening to their music in the Albert Hall. There were many other actors and musicians who appeared in the Pavilion during these anxious years. Reginald Stead had become a member of the Halle Orchestra in 1930 and immediately the war ended he became the able leader of the BBC Northern Orchestra, where he remained for the next twenty six years.

CABIN HILL AND THE BATH BOYS

The proprietor of this small hotel (now 16 College Avenue) in Rhos-on-Sea, which advertised a 'Variety of Food and Invalid Cooking a Speciality', was the epitome of the grit and determination required by those who remained at home during the war. Mrs Dodd was a wonderful cook and before the war her guests were people who returned regularly each year, invariably for the same dates. Henry Hall, the band leader who led the BBC Dance Orchestra and who during the war toured incessantly to entertain the troops, would arrive with his wife and his son Michael, every year to stay for a week at Cabin Hill. Mrs Dodd had two daughters, Ida and Amy (later to become Ida Beardsall and Amy Fairclough). The whole family, with other friends such as Jane Davies, attended Rhos-on-Sea Congregational church in the church school room on the corner of Penrhyn Avenue and Colwyn Avenue, just around the corner from Cabin Hill. Amy Dodd, Jane Davies and others would serve beans on toast, augmented with Mrs Dodd's mouth-watering concoctions, to troops returning from Dunkirk and the flotsam and jetsam of the fighting men and women who came and went with ever-

Cabin Hill, thirty-six years after the war ended

increasing frequency. During the war Mrs Dodd kept a diary, which included a list of the recipes she had been able to put together from the ingredients that Lord Woolton had decreed she and all other housekeepers could use. Imagine the good fortune of the civil servants and service men who were billeted with Mrs Dodd. There were so many civil servants and service men swishing around the district that they found it difficult to have a bath, so certain establishments, such as Cabin Hill, had a regular list of men who would arrive once a week at an agreed time for their bath. They were known affectionately amongst these matrons as 'our bath boys'. Some proprietors offering the bath facility advertised in the local cinemas.

THE IRONY OF THE PEACE

What the Germans were unable to do between 1914 and 1918 and then between 1939 and 1945, to subjugate the British people, was nearly achieved by nature, by the twin forces of influenza and an arctic winter.

In 1918 four million men returned home from the army and navy and a further three million munitions workers were without jobs. Just as these men were hoping for better days, influenza started to seep into the towns and villages of Britain. The huge crowds that gathered to welcome home these brave men were unwittingly helping to spread the disease. In January 1919 the *Hackney Gazette* commented, 'This adds a new danger to life. One is never safe in this world.' By the spring of 1919 two million people in Europe had been killed by the disease and in the United States of America five times as many people had succumbed to the disease as had perished in the Great War.

The winter of 1946 was one of the coldest on record and was known as 'Shinwell's Winter' because Emanuel Shinwell happened to be the Minister of Power and Fuel at the time. There was a fatal lack of fuel as lorry loads of coal struggled to get through to power stations. Domestic electricity was only supplied for nineteen hours a day and the supply to industrial sites was cut completely. Radio broadcasts were limited and the editors of magazines were told to stop publishing their periodicals. Hitler had been unable to dent the morale of the British people, but these conditions were a severe jolt to everyone. Emanuel Shinwell became a scapegoat; he received death threats and had to be placed under a police guard. His political career never really recovered. There was a widely held fear that there was going to be a life-threatening food shortage as most of the crops were frozen into the ground. For six years the civil servants of the Ministry of Food in Colwyn Bay had struggled valiantly and successfully to feed the people of the British Isles and now that peace had returned the weather had demonstrated how vulnerable we had been all along.

9 June 1943. The visit of the Minister of Aircraft Production, Sir Stafford and Lady Cripps (centre), and Sir Henry Morris-Jones MP (far left) to the Braid Garage munitions factory.

ACKNOWLEDGEMENTS

I am grateful to the following people for their help and for allowing me to share their memories: Kenneth Dibble,(of the Animal Feeding Stuffs Division): Lionel Johnson, Olive Roberts (née Gatley of the Catering Division), Dr John Wainwright, the Braid family, Dilys Thomas (née Roberts), Muriel Hughes (née Davies), Milburn Shanks, Cec Owens (of the Oil & Fats Statistics Department) & Brenda Owens (née Powis); John Hughes, Jack Simms, Joan Verner Parsons (née Rees of the Bacon & Ham Division); Joyce Davies (née Wheatcroft), Robin Chapman (née Meredith); Laurette Valentine Danson MBE (née Prendeville of the Wheat Commission); Fred Davies and Aline Davies (née Firth whose wedding reception was in the Pavilion on the Pier); John Barlow and Joan Stevens (née Barlow) of the Meadow Croft Hotel; Vincent Kift, a child of parents who met in The Queens Hotel; Roy Wooller; Anne Wells (née Williams); Olwen Owen (née Hughes); Fred Pollitt: Megan Conway (née Roberts); Margaret Eleanor (Peggy) Boden, of the Welfare Foods Division; Kathryn Lea (née Newton); Joyce Spencer-Williams; Jean Woolley (née Davies who remembers the Bath Boys); Vera Wellings (née Travers); Joyce Lumley Davies of the Cereal Product Division; Arthur Lloyd; Audrey Andrew of the Milk Division: Grace Hall (née Boyce of the Canned Condensed Milk Division); Bill Calder; Elizabeth Violet (Betty) Dale (née Tuczek of the Butter & Cheese Department); Colin Jones (Geoff's son); Constance Crook (née Llewelyn, who stayed in Chatsworth, the Duke of Devonshire's home); Joan Sattler, (née Bellis of the Ration Book department): Margaret Logan (née Whitley) and her cousin Alice Worth (née Williams); Margaret Butler (née Bower, whose father ran Littles provision shop); Diana Flynn: Colin Williams: Jos (Joseph) Williams: Hetty Harley (née Ellis, who was too young to fraternise with the Yanks): Gwyn Williams (a police constable during the war): George Walsh (a gas mask carrying pupil at Conway Road School in 1940): Eirwen Jones (née Hughes, who manned the Metropole 'tuck shop'); Terry Deakin; Gillian Akka and Vivien Marshall (children of the Jewish community); Brian and Rosemary Sutton of Dolwyd Farm; Yvonne White of the Egg Division; Gwilym Pritchard.

I am grateful to the following people for allowing me to use their photographs: John Barlow; the Braid family; Fred and Aileen Davies; Ken Dibble; Councillor Philip Evans JP; the late Frank Geck; Ken Hughes; Paul Moffatt; the late Kathryn Newton; Joyce Spencer Williams; Tony Wilkinson; Chris Reynolds; Mr R. Tickner the archivist at Rydal Penrhos School.

BIBLIOGRAPHY

Andrew, Audrey, *Private diary: 1940-1944*

Braithwaite, Brian, Walsh Noelle, Davies Glyn, *The Home Front* (1987)

Collingham, Lizzie: *The Taste of War* (2011)

Chrimes, Harry B., *A Memoir of Sir Bertram Chrimes* (Chapter 7) (1989)

Davies, D. Wheway, OBE., *F1 Firec E, Early Fire Service History in Clwyd Area* (1980)

Fearnley-Whittingstall, Jane, *The Ministry of Food* (2010)

Gardiner, Juliet, *Wartime Britain 1939-1945* (2004)

Gardiner, Juliet, *The Blitz, The British Under Attack* (2010)

Groves, Vic, Private Autobiography, Chapter 33 (1979)

Hammerton, Sir John (Ed.), *The War Illustrated & Afterwards; a Fortnightly periodical* (1943-1945)

Hastings, Max, *Finest Years, Churchill as Warlord 1940-45* (2009)

Kift, Esyllt: *A Dream Becomes a Reality* (1967)

Lowe, Cindy, *Colwyn Bay Accredited, The Wartime Experience* (2010)

Mellor, George, *Colwyn Bay Cricket Club, A Club History* (1992)

Morrison, Herbert, *An Autobiography* (1960)

Rhos-on-Sea Bowling & Tennis Club Golden Jubilee Booklet (1973)

Park, Nancie, *School Days At Chatsworth* (1986)

Poynton, Turid R, *The Edelweiss Hotel, A Brief History* (1999)

Roberts, Eunice & Helen Morley, *The Spirit of Colwyn Bay*, Vols 1 & 2 (2003)

Roberts, Graham, *Colwyn Bay & District, A collection of pictures* Vols 1–3: (1991–1997)

Roberts, Graham, *Colwyn Bay Through Time* (2009)

Rydal Penrhos News Magazines

Smith, Daniel, *The Spade as Mighty as the Sword* (2011)

Smith, Lyn, *Young Voices. British Children Remember the Second World War* (2007)

Swainson, Mary, *The Life & Times of Penrhos College, 1880-1995* (1996)

Thomas, Dilys, *Memories of Old Colwyn* (2000)

Thomas, Dilys, *Old Colwyn, Then and Now* (2009)

Wallace, William: *Enterprise First* (1946)

Williams Lt.-Col.John R, *No.1 Battalion (Denbighshire) Home Guard* (1943)

Williams Lt.-Col.John R, *An Autobiography* (1953)

Worth, Alice, *War Time Memories*

Wynne-Jones, Ivor, *Hitler's Celtic Echo* (2000)